*FÜR
SCHEINBERGER*

URBAN
WATERCOLOR
SKETCHING

A Guide to Drawing, Painting,
and Storytelling in Color

WATSON-GUPTILL PUBLICATIONS
Berkeley

CONTENTS

INTRO

06 Watercolors—In or Out?

08 A Painting for the Emperor

10 Gum Arabic: Where the Watercolors Grow

12 Pigments: The Stuff That Dreams Are Made Of

14 Yellow and Orange: Of Camels and Crocuses

16 Red and Purple: Of Bugs and Snails

18 Blue: Of Lapis Lazuli, Indigo, and Woad

20 Green: Of Plants and Poison

22 Introducing Color to Sketches:
We're Not in Kansas Anymore

FIRST ATTEMPTS

24 Multiple Choice: To Design Is to Decide

26 From Dusk till Dawn: Shadows and Light

28 Black Is Back: Glazing with India Ink

30 Layer for Layer: The Glaze

32 Mixing Colors with Glazes

34 Fish Soup: Practicing the Glaze

36 The Wash: The Paint Does as It Pleases!

38 On the Run: Graded Wash Techniques

40 Once More, with Feeling!: Washes

42 It's a Give and Take: Applying and Removing Paint

44 Wet-on-Wet

46 Combining Techniques: A Little Bit of This and That

EXCURSION IN COLOR THEORY

48 Where Do Colors Come From?:
The Simple Science

50 Arranging Colors

52 Opposites Attract: Color Contrasts

54 From South Park to Stoplights: Types of Color

56 True Color: The Effect of Light

58 Every Color Tells a Story: Intensifying Your Sketches

60 It's All Relative: The Effects of Colors

62 Color Harmonies: Simple and Complex

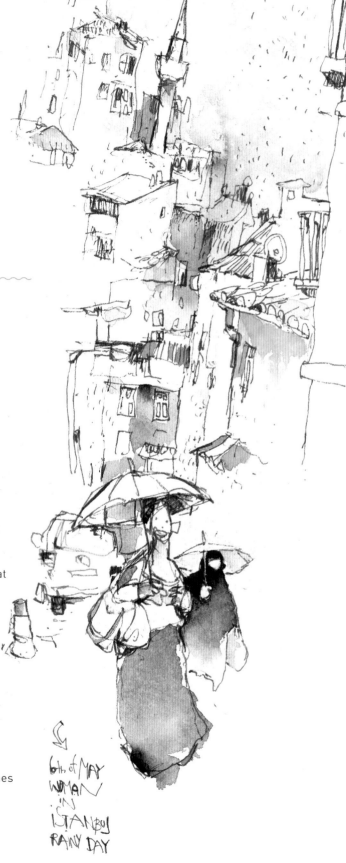

6th of MAY
WOMAN
IN
ISTANBUL
RAINY DAY

64 Analogous, Monochromatic, and Complementary Harmonies

66 Triadic and Tetradic Harmonies

68 Cool-Cool and Warm-Warm Harmonies

70 Collecting Colors

72 Designing Color Harmonies: Working with Color Code Strips

74 Getting Out of Your Color Comfort Zone

76 The Blue Ridge Mountains: Color and Perspective

YOUR OWN STYLE

78 Less Is More

80 Me, Myself, and I: Finding Your Own Style

82 Style and Creativity

84 Throwing Down: Loosening Up Your Painting

86 Seek Not and You Shall Find: Imagination vs. Internet

88 Make It Matter

90 Priorities

BASICS / TOOLS

92 Paintboxes

94 Watercolor Pencils

96 Buying Paints

98 Mixing Paints

100 Impossible Hues: Bright Colors

102 Pimping Watercolors: Making Colors Pop

104 Liquid Watercolors: Bright Now, Pale Later

106 Into the Wild: Brushes

108 Even More Brushes

110 Paper

112 The Permanent Wave: Stretching Paper

114 The Contents of My Bag

OUT & ABOUT

116 Bad Weather: Painting Outdoors

118 The Other Viewpoint: Changing Perspective

120 Painting Water

122 Air, Fog, Smoke

124 Smog and Atmosphere

126 What Is Beauty Anyway?

TIPS & TRICKS

128 Composition and Design

130 Smudges and Spots

132 Painting What's Not There: Negative Space

134 White: A Special Case

136 Studies, Sketches, and Drafts

138 Undo

140 Merging Colors: Working from One Color

142 Working with Colored Paper

144 Special Effects

146 Lettering and Writing

148 Layouts, Scribbles, and Storyboards

150 Watercolor Illustrations

152 How Much Is Your Picture Worth?

154 Everything Ends: When Is a Picture Finished?

155 Index

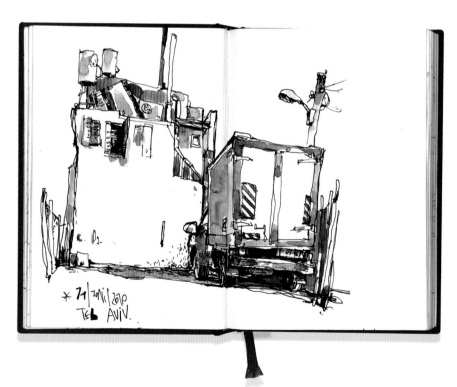

WATERCOLORS— IN OR OUT?

When we think of watercolor, many of us immediately picture sentimental landscapes and paintings of ruins and picturesque scenes. Although eighteenth- and nineteenth-century English artists established watercolor as a sophisticated painting medium, it often yields strangely negative reactions from contemporary artists. An entire generation quickly relegates it to a hobbyist's medium.

Yet watercolor is far more than an amateur's medium, as it requires intense concentration and practice. Once it's put on paper, mistakes are difficult to remedy, and only when it is applied with confidence does it have a truly successful effect. Watercolor involves a certain degree of uncertainty, but it also teaches us to see.

Watercolor was the first technique to free the artist from the studio because it could easily be taken outdoors. It required no tubes, easels, canvases, or similar implements, only a box of paints and paper. Even today, watercolor is a tool that frees us from the studio, our laptops, and countless charging cables.

Watercolor is, however, not just a technique; it is almost an attitude. Watercolor always does what it wants. In a way, it is willful and anarchical. Therefore, for me, the secret to using watercolor to create pictures lies in striking a balance between control and letting go. Pictures are often only "really good" when they surprise us—when they reveal what we sensed and felt, but could not have consciously expressed. If we sacrifice the right amount of control in the artistic process, watercolor's inherent qualities begin to work to our advantage.

This book has two goals: to teach you watercolor techniques and to tell you something about color.

However, it does not aim to explain, for example, how you can paint a certain sky in four steps. I seriously doubt whether readers learn more from such instruction books than they do by actually painting that sky. What if the sky should suddenly cloud over? Instead, this book wishes to show you the basic principles of watercolor paints, so you can flexibly apply them to whatever you want to achieve.

I imagine it's a little like learning chords on a guitar. For me, it seems important that you learn the fingerings, but what song you play is up to you.

And don't worry, everything that we need to know about color can be learned with a simple box of paints.

Whether watercolor painting is sophisticated and legitimate or not isn't the point. Watercolor can go anywhere. It is an autonomous, free, and creative medium. It makes the world our studio.

Yours truly,

Felix Scheinberger

A PAINTING FOR THE EMPEROR

This story was passed down from ancient China. An emissary of the emperor visited a famous painter one day.

The emperor desired a painting, the emissary told him, asking him whether he could paint a rooster for his majesty. The painter replied that he could do so, but it might take him awhile, for a good picture needed time.

Now, the emissary knew that the emperor was not blessed with much patience, so he granted the painter two weeks to paint the rooster.

When the two weeks had passed, he appeared again.

"Where is the rooster?" he asked the painter, who replied that he was working on it, but the picture was not yet finished. The emissary cursed, but granted the painter another week, since he was aware that the painter was a great master of his craft. For his part, the painter vowed to finish the rooster in time. However, when the week was over and the emissary appeared again, the picture was still not completed. The emissary ranted and shouted, but nothing helped. The painter demanded yet another week to work on the rooster.

Now, the emperor was not accustomed to waiting, and when the week had ended, he arrived in person, accompanied by his royal household, to visit the painter.

He inquired whether the rooster was now finished.

The painter lifted his face and responded: Yes, indeed, the rooster was now finished. And before the eyes of the perplexed emperor, he took an empty sheet of paper, picked up a brush and painted a rooster for the emperor.

The emperor was speechless. He barked at the painter: Why did he allow his emperor to wait so long for something that he could paint here and now, at the drop of a hat? The painter remained very calm. He crossed his studio and opened a door to a rear room. And, as all present looked into the room, they could see a space as large as the painter's studio that was full to the ceiling with weeks' worth of sketches, attempts, and drafts for the emperor's swiftly painted rooster.

This story has a great deal to do with watercolors. Watercolor involves techniques that require some time to fine-tune. It does not, however, take much time to actually paint with watercolor; it is a very fast, immediate medium. Nevertheless, no matter how little time it takes to paint, it's important to take the time to practice and get the hang of the techniques. To be frank, this may not be the advice people expect from a watercolor instruction book, which, by nature,

GVeoNGBok PALACE 13th of NOVEMBER
SEOUL, KOREA
THE INNER COURT

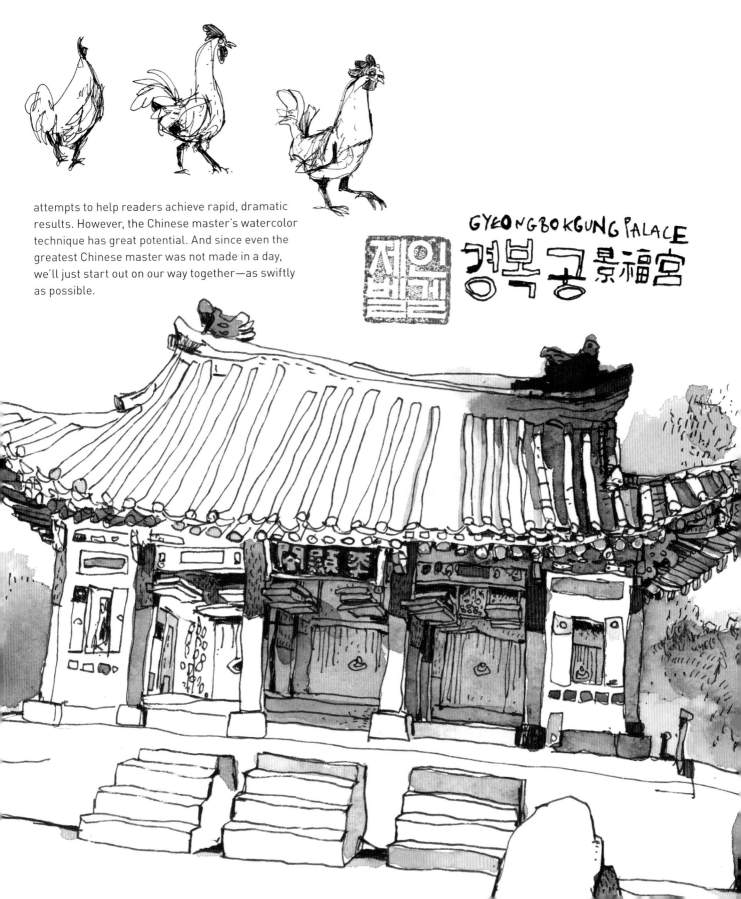

attempts to help readers achieve rapid, dramatic results. However, the Chinese master's watercolor technique has great potential. And since even the greatest Chinese master was not made in a day, we'll just start out on our way together—as swiftly as possible.

GYEONGBOKGUNG PALACE
경복궁 景福宮

GUM ARABIC
Where the Watercolors Grow

It is hot where the watercolors grow, and if there is one scarce commodity, it's water.

Sudan is one of the world's harshest regions: a semi-desert region in northeast Africa with sandstorms and temperatures that have reached as high as 120 degrees Fahrenheit.

However, the substance watercolors are made from comes from the heart of Sudan, from Kordofan, Kassala, and Darfur.

To understand how paints work, we must first look at what they are made of. Watercolors are one of the oldest kinds of paints, and their secret lies in an amber-like yellow substance that has made its way from the far away, hot desert to our paint-boxes. We'll get to that in a bit.

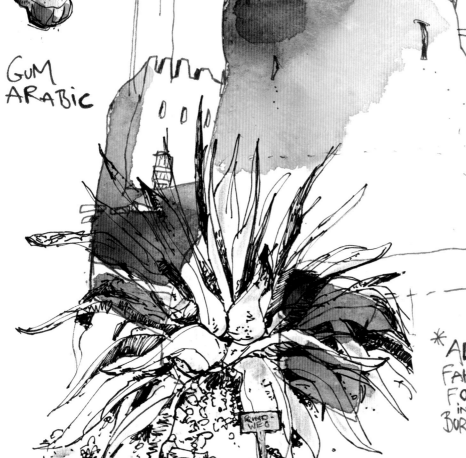

GUM
ARABIC

* AL
FAHIDI
FORTRES
in
BUR DUBAI

20/1

Paint begins with pigment, a material that usually comes in powder form and that vibrantly reflects a particular color. This powder is the actual dying agent. It can come from a plant or mineral, a metal, or an oxide. Paint contains hundreds of organic or inorganic substances that all originate in powder form—and thus pose a problem for the artist, since powder does not readily adhere to the support (that is, the paper or canvas).

To become what we recognize as paint, the pigment needs an adhesive, a "vehicle," to hold the paint together and adhere it to the paper after drying.

Over the centuries, people have constantly been inventing new ways to solve this problem. In the Middle Ages, artists used egg yolks, to which they added pigments in order to make egg tempera. During the Renaissance, they used boiled linseed oil to create oil paints.

It is actually the vehicle, or binder, that distinguishes one type of paint from the other. Whether a pigment is turned into acrylic paint or oil paint, whether it is pressed into a colored pencil or the shape of a wax crayon depends on the binder.

Watercolors are made of a resin, called gum arabic, which, as we mentioned, comes from Sudan. The small, thorny trees from which it is harvested are called Acacia seyal (red acacia) and Acacia senegal (gum acacia). The bark of the tree is cut into at a downward angle and releases a milky juice that is collected and dried. This dried and ground resin has served as a binder for paints from time

immemorial. The ancient Egyptians also used it in their mummification processes, and the Chinese mixed their ink in it.

To make watercolors, the odd honey-colored resin chunks are ground and dissolved in warm water, to which pigment powder is added. Watercolor paint is basically still manufactured in the same manner as it was a thousand years ago, because there is no appropriate chemical substitute for gum arabic.

Gum arabic is unique: the binder is translucent and reflects light. This intensifies the luminosity of the paint. Also, gum arabic is nontoxic and can be redissolved in water after it dries.

Gummi ARABICUM

★ THE GUM is GROUND + DISSOLVED IN WARM WATER

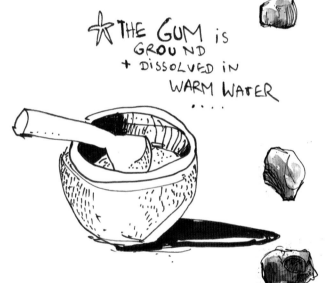

PIGMENTS
The Stuff That Dreams Are Made Of

The idea of mixing pigments and gum arabic together to make watercolor paint is very old. But at the beginning of the nineteenth century the English chemists W. Winsor and H. Newton were the first to add glycerin to the blend to make the paints maintain a semi-moist consistency when stored in paintboxes. Honey has also been known to achieve this effect.

The actual dye, or what gives the paints their color, is the pigment, which is separate from the binder.

Pigments come as very finely ground, colorful powders. They are created from ground organic and inorganic substances, which are later mixed with a binder to make paint.

There's a reason why, over centuries, pigments were highly commodified and considered a well-kept secret of painting. Pigments are colors that—as strange as it sounds—stay colorful.

Colors are everywhere. Flowers represent an array of colors, as do fruits, fields, forests, the light of sunsets, spectacular birds, and butterflies. The problem with these colors, however, is that they do not last. Every time winter comes along, the colors disappear. When the sun goes down, there is only night. If something living dies, its colors fade: flowers wither, fruits lose their colors, and, when fall comes, the green of spring transforms into earthy hues.

→ PLASTIC ★
SOVIET ☆ WATERCOLOR
BOX c. 1980
ЛЕНИНГРАД

It can be difficult to make colors hold permanently. For example, if we squeeze a red fruit, its juice is probably also red at first. But this color gradually fades as it dries. And if we deliberately expose the dried juice to light, its brilliance fades more and more with time. It will probably soon become brown or gray and will certainly not glow as it did shortly after pressing.

Most colors fade, which is a problem for artists who want their sketches and pictures to remain luminous and vibrant.

To a great extent, light is responsible for most paints losing their color. Though paints may glow in the light, they are also destroyed by it. If you expose paints to light and air for a long time, they fade even more rapidly. The effect is lesser for inorganic pigments, oxides, or earth colors, but many of these paints, too, fade with time.

However, there are also "lightfast" paints that resist fading and are made from special pigments.

Pigments can be made of organic and inorganic substances—of minerals, plants, or even insects—and they can also be chemically manufactured. Watercolor paint is usually made of chemical pigments that are ground particularly fine to allow for optimal glazing capabilities. Usually the paints in our palettes today contain very large amounts of pigment, so even in tiny amounts, they provide an adequate punch of color.

Pigments are the true soul of the paints. When combined with gum arabic, glycerin, and honey, they breathe life into your pictures.

And one more thing:

Watercolor paints may change color as they dry. Many shades alter only slightly, so while this does not mean that a red will suddenly turn green, it can, for instance, look duller once it dries. The only thing that can help you anticipate this change is experience. In time, you will get to know your paints better and will be able to work with these particular characteristics.

YELLOW AND ORANGE
Of Camels and Crocuses

There is a story about Indian yellow that has made its way into almost every book about color.
As the story goes, Indian yellow first came from camels that were fed a steady diet of mango leaves and were not given enough water.

The urine of the poor creatures was then heated to produce a pigment of intense yellow color, called *purree*. This method was banned in the early twentieth century because it was inhumane.

For obvious reasons, there have been more and more doubts about this tale in recent years.

For one, in India the story is unknown or known only from European sources. And since mango leaves do not really have dying capabilities, we can assume that the yellow color probably came from minerals or calcium phosphate to which urine had been added. It's possible that the bit about the camel was added to make the pigment more interesting and therefore more expensive.

Yellow is the lightest of the primary colors and therefore the most sensitive to blemishes and clouding. Even the tiniest impurities can make yellow shades appear dirty or weak. For centuries, yellow pigments were made from toxic arsenic, cadmium, or chromium. Alternative dyes, such as saffron (which comes from the pollen of the saffron crocus) were expensive. Furthermore, only very white (and therefore very costly) fabrics could be dyed yellow since the smallest impurities would cloud the color's brilliance. Thus, in ancient China only the emperor and religious dignitaries were permitted to wear yellow robes, which were dyed with saffron.

Then again, in medieval Europe the color yellow also had negative connotations. When yellow flags waved above a city, it meant the Black Death was raging there.

You only need two yellow tones in your paintbox, cadmium yellow or pure yellow and Naples yellow. Actually, the white content of Naples yellow makes it break into a pasty hue when mixed with other colors, forming, for instance, dramatic grays for stormy skies.

The story of orange pigment begins in ancient times, more precisely in the first century AD during a fire in the harbor of Athens. Barrels of white lead pigment are reported to have burned in the fire. When the Athens harbormasters inspected the damages after the fire was put out, they were surprised to see the change in the white lead. It had turned a reddish-orange color and went down in history as "red lead."

Beautiful women and gladiators used it as makeup, walls were painted with it, and books were illuminated with it. Sadly, it was discovered that red lead is extremely toxic and it disappeared from paint sets in the twentieth century.

Orange was also often manufactured from safflowers or the resin of the dragon tree. It is not quite clear whether the color orange was named after the fruit or vice versa. It is believed that the fruit originated in Asia and was probably common in Europe after the Renaissance. The French city of the same name may also have been the eponym (it has oranges in its coat of arms), since it lies close to the ocher quarries of Roussillon, where orange and red pigments had been mined for centuries.

For a long time, orange was not considered a color on its own but rather reddish-yellow, and was categorized with one of these two colors depending on its saturation. Orange did not debut as an individual color until modern times, when it was used extensively in the works of Vincent van Gogh and Edvard Munch. Orange is easy to mix, but it is best to have a premixed orange in your set for fast painting.

Tip: Yellow is very sensitive to impurities. When painting, make sure not to dip your brush into yellow if any other paint is already on it, and use lots of fresh, clean water when working with yellow.

RED AND PURPLE
Of Bugs and Snails

We see red when light above the spectrum of 600 nanometers meets the cone photoreceptor cells on our retina.

By contrast, the color red—at least in its most basic form—is fairly down-to-earth.

Red earth containing an iron oxide called hematite has been used by people since the Neolithic era. Depending on the shade, it can be either used as is or burned to make Indian or English red.

However, bright red cannot simply be mined. Ocher red is always a bit earthy, a shade between rust and autumn leaves, but never what we would consider as bright red. Though it may sound strange, red was obtained from cochineals for millennia—and not from just a few of these bugs, either: to make 3.5 ounces of color, you'd need about 14,000 cochineals, each of which had to be gathered from plants (usually certain grasses or from the prickly pear). Dried and pulverized, they provided the raw material for purple, crimson, and scarlet.

The rubia plant provided another source of red. Used since ancient times, it can still be found today in your watercolor set as alizarin crimson or rose madder.

Purple, which the Romans used to dye their togas, was also difficult to obtain. In ancient times, the secretions of a small sea snail were used to create the purple dye known as murex.

In this case, the ratio of color to animal was even less favorable: for 3.5 ounces of dye, 100,000 snails had to sacrifice their lives.

Interestingly enough, although we consider red a warning color, most other mammals can hardly see it. Humans are an exception.

Birds, however, can see red very well, which could be why birds flock to fruit that is red.

Corydoras arcuatus

CAMEL
MARKET
1216

Recommended
reds and purples for
a medium-sized
paint set: cadmium
red, alizarin crim-
son, magenta, and
manganese purple.

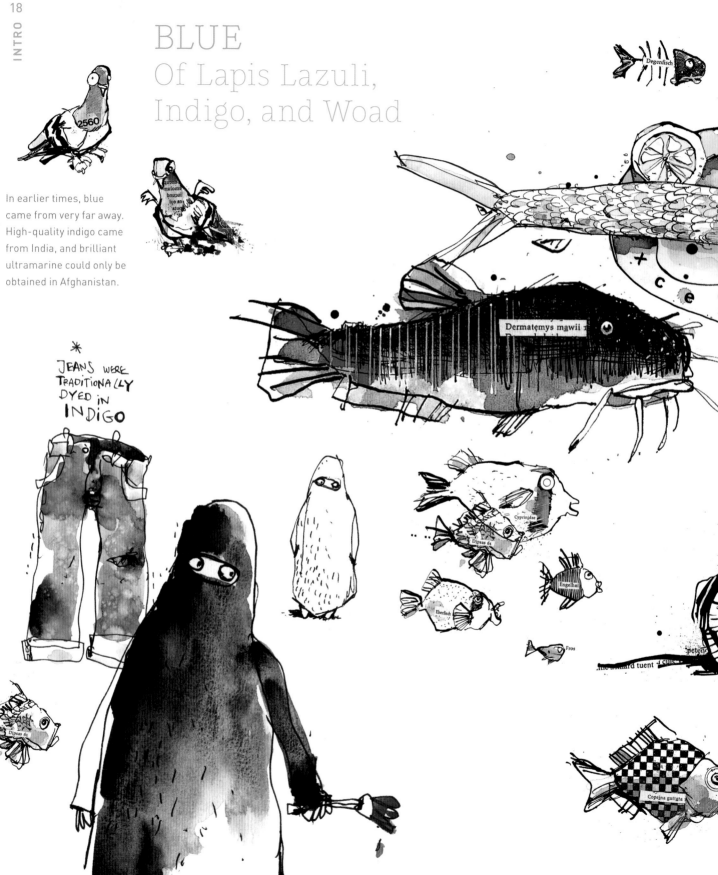

BLUE
Of Lapis Lazuli, Indigo, and Woad

In earlier times, blue came from very far away. High-quality indigo came from India, and brilliant ultramarine could only be obtained in Afghanistan.

JEANS WERE TRADITIONALLY DYED IN INDIGO

In the past, blue posed a problem for painters, not because it is a melancholy color (there's a reason we call it "the blues"), but mainly because of the expense. Nothing was as costly as pure, brilliant blue. Blue was the color of princes, Madonna statues wore blue robes, and of course the name "royal blue" did not come out of the blue (pardon the pun).

Once upon a time, pure blue could only be made two ways. One way was to mix the leaves of the dyer's woad plant with urine and ferment the mixture. The alternative was to obtain the ground pigment of a precious stone that only came from one single, inconceivably remote Afghan mine. Ultramarine, or lapis lazuli, was more precious than gold, and it passed through the hands of many people before it even reached painters.

So, blue was a problem. Intense blue was practically unattainable and dull-blue indigo produced nauseating smells when it was made. Starting in the Middle Ages, indigo came from India, where a variety of woad was discovered that had much stronger dying capabilities than the Central European variety. This indigo eventually replaced traditional dyer's woad.

Blue is irreplaceable as a primary color for painting. In my opinion, a good group of blues to include in your paint set consists of cobalt blue, ultramarine, and indigo. Turquoise is also good to have since it is a difficult color to mix yourself.

P.S. A person is "blue-blooded" when they do not have to work outdoors in the sun and their veins shine through their pale skin.

Tip: Blue tones are very intense in color and therefore offer you a marvelous range of shades. A dark blue (such as indigo) can almost look black, while delicate shades can almost appear white. That is why blue is great for portraying subtle nuances in color.

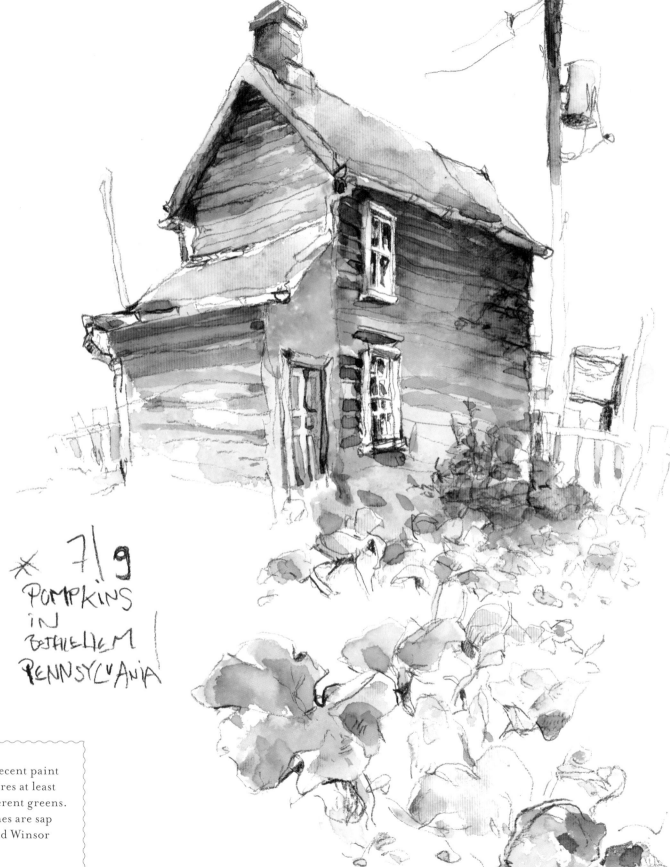

✳ 7|9
POMPKINS
IN
BETHLEHEM
PENNSYCVANIA

Tip: A decent paint set requires at least two different greens. Good ones are sap green and Winsor green.

GREEN
Of Plants and Poison

Green is not only a dominant color in landscapes, trees, and fields, but also represents an essential part of nature.

The green chlorophyll contained in leaves produces oxygen, making life on earth as we know it possible.

It is hardly any wonder then that green is considered a sacred color in many cultures. Green is particularly esteemed in places where it is rare in the landscape, such as desert regions.

Yet, although green is considered the color of nature, for centuries it has also been associated with something deadly.

Poison is sometimes portrayed as being green, mainly because green pigments used to be made of toxic metal oxides, such as copper oxide dissolved in arsenic. Licking or chewing on a paintbrush would have cost painters their lives in olden days.

Today it is conjectured that Napoleon's choice of interior design killed him in the end, since the wallpaper in his home was green, treated with a dye that contained arsenic.

Using green is more difficult than one might imagine. In a painting, green that isn't carefully blended can quickly appear unnatural.

For instance, if you paint a tree just with light green, it will look like plastic.

So try breaking the green up a bit—especially for paintings of nature. Try mixing a small drop of yellow or of green's complement, red, into the paint and your meadow will immediately look more natural.

TLINGIT MASK

MASK OF THE SPIRIT OF THE SEA KWAKIUTL INDIANS

AND CEREMONIAL COST

INTRODUCING COLOR TO SKETCHES
We're Not in Kansas Anymore

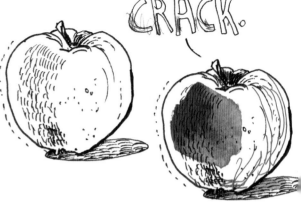

What is responsible for such a dramatic change when we switch from black and white to color? How can we explain the big difference between a drawing and painted picture?

Compared to paintings, drawings sometimes seem oddly aloof. This changes abruptly once color is added. Color is alive; it's emotional and brings us to an entirely new place.

Take a look at a drawing and then at an image with color and I'm sure you'll see what I mean.

A drawing—and even more so a sketch done in pen or pencil—conveys something that is hard to grasp, something that seems indefinite. When color is added, in a manner of speaking, we enter the "real world."

This may be due to the fact that black-and-white drawings work on a strangely distanced and circumscriptive level. Through lines and outlines, drawing defines the world quite differently than painting does. Drawing remains in the realm of planning and drafting.

Reality is colorful. With the exception of hyper-realistic drawings, the drawing medium serves better for drafts or models for colored images.

Painting attempts to create illusion, while drawing mainly explains.

Painting is a risky medium, but also a wonderful one. Color is demanding and enriches our pictures with a sensual aspect.

A drawing of a cake merely describes its shape, but a painting of a cake makes it mouthwatering. Drawing is a model; painting is the world. So, let's come out of hiding.

Drawing with color added. The cookie "comes alive" in those places where the drawing is emphasized by colors. In addition to creating a sense of space, paint also creates a sensual effect: the cookie becomes appetizing.

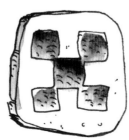

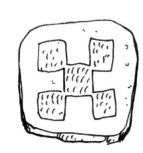

Chomp

CHOMP×
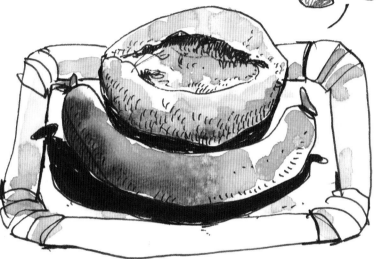

FIZZ PLOP

MULTIPLE CHOICE
To Design Is to Decide

**First and foremost, the process of design involves
decisions and understanding how we make them.**
Our result evolves according to the path we decide to
take. More blue, more yellow. It is your picture and you
alone decide what it will contain.

Of course, that's what makes designing a picture so
difficult.

Artists compose worlds and populate them with sub-
jects. In doing so, they make countless little decisions:
the color of the sweater or the car, the sizes of the indi-
vidual elements, and how important single colors or
shapes are.

Thus, your sketch is the result of a series of choices.
Only from the outside and to unknowing viewers is it a
closed, final work. You, however, perceive it more as a
chain of decisions in the creative process. This is the
actual difficulty of art, because decisions can be so
hard to make.

Why is this so?

Our worldview is what makes decisions so hard. Since
ancient times, our way of seeing the world has been
marked by polarities. We think in terms of light and
dark, good or evil, heaven or hell. And under the
assumption that every coin has two sides, we unknow-
ingly develop the idea that anything but the "right"
decision is "wrong."

Stop!

There is no right or wrong in painting. Every design
decision contains countless possibilities and
subtleties.

Therefore, my advice is to not think in terms of
results, of "finished pictures," but rather in terms
of hundreds of minor intermediate steps.

Once you get on your way, your picture will grow
on its own. And usually decisions are only hard to
make during the initial stages—once you begin,
everything will seem easier and you will be amazed
at how easy painting can be. With a little practice,
you will carry this ease into your next picture, as
well—with all its countless decisions.

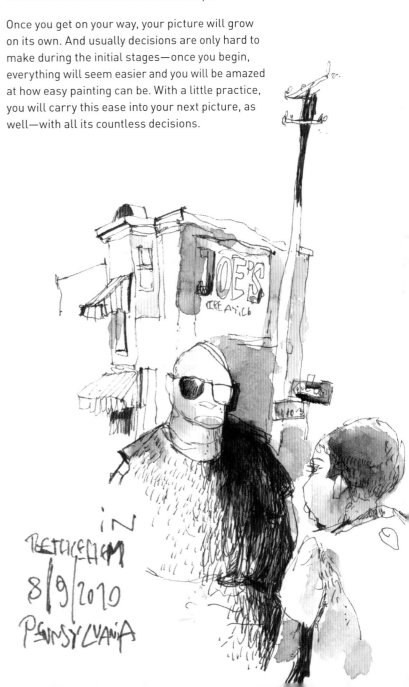

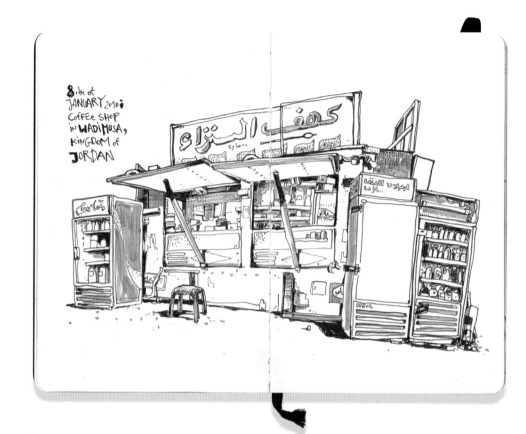

Jordan sketchbook.
Medium: black fine-tip pen and felt pen on paper. The gray areas were added quickly and economically.

Jerusalem sketchbook.
In this case, a felt pen was used to fill the gray areas (cap and sweater) more extensively.

FROM DUSK TILL DAWN
Shadows and Light

Tip: One way to develop a good feel for gray or midtone areas is by studying old black-and-white photos.

It's pretty simple: shadows are where no direct light falls.

This explains almost everything you need to know about painting.

Producing a sense of space with watercolor mainly involves painting the shadows. Don't worry so much about painting the light since the lightest color in a watercolor painting is just the white of your paper. The contours are established by your drawing, and the glaze is what builds a bridge between the light and contours.

To get a bit of practice and a feel for the phenomenon of the glaze, our first step isn't just to switch off the light with lots of paint. Instead, we'll start with a small shadow.

The simplest exercise for this requires a felt pen.

Try giving your existing drawings (in your sketchbook, for instance) a second tone, a midtone, for example. Use a felt pen or a marker with a medium-gray shade (like light gray) to add gray areas to the sketch. In order to register the shadows of the real-life subject you are drawing, try squinting your eyes a bit. This simplifies your view, intensifies the grays, and makes it easier for you to copy them onto the sheet. You'll suddenly notice how this enhances your drawing. The glaze then gives these shapes a sense of space and dimension, and your drawing gains depth.

"TEXAS-BAR"
SEOUL KOREA
13/11

→ YOU CAN MIX IN THE LID !

BLACK IS BACK
Glazing with India Ink

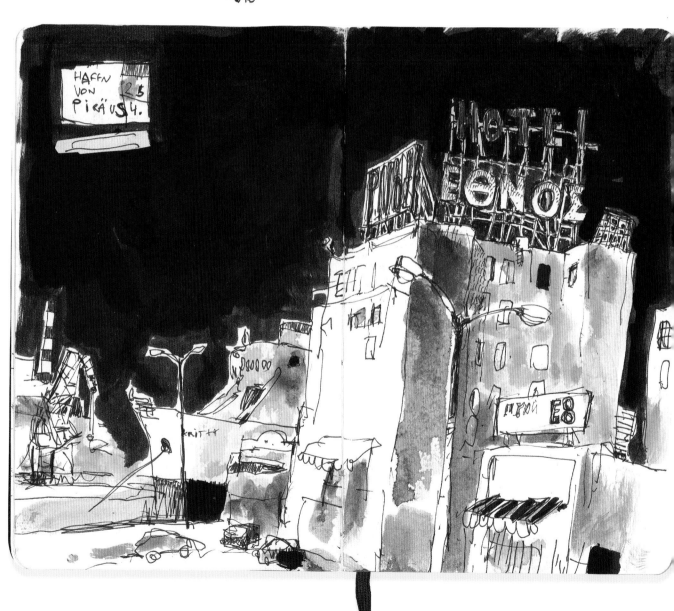

Simply put, India ink is just like an old school magic marker.

The gray areas a marker can make can be created just as well with a brush and diluted ink. Not only that, but ink has an additional underestimated advantage: you no longer need an assortment of markers in various shades. With India ink, you can simply mix a shade yourself. This makes it easy to achieve various shades between light and dark. The more water you use, the lighter the shade. You can produce countless gradations with a single pot of ink.

In this way, India ink is a good intermediate step toward working with watercolors, since it works like a glaze but allows you to experiment with shades and different values.

In terms of its composition, India ink is a blend of soot, water, and a binder, such as shellac, acrylic, or gum arabic. To obtain black, burnt wood or iron was used, and burnt bones and charred ivory produced very deep black tones. For browns, ash from beech wood, called bister, was used. Two other "classical" types of ink were sepia ink—a brown made from cuttlefish ink—and gold ink made from arsenic and mercury.

Of course, these rustic-sounding materials are things of the past. But little has changed over generations in terms of ink's practicality and versatility as a drawing and painting material.

The only disadvantage is that ink stains. Maybe this is why painters always wear black.

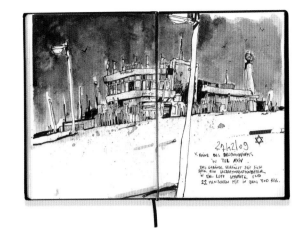

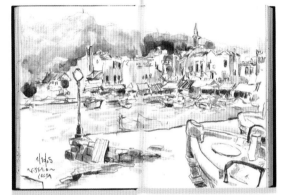

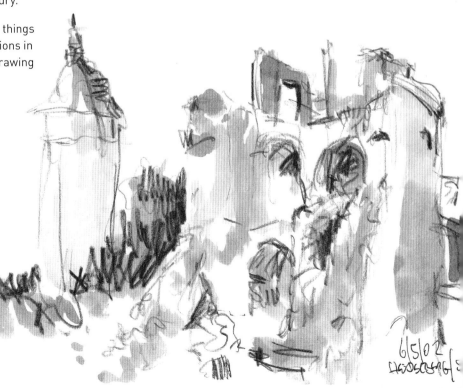

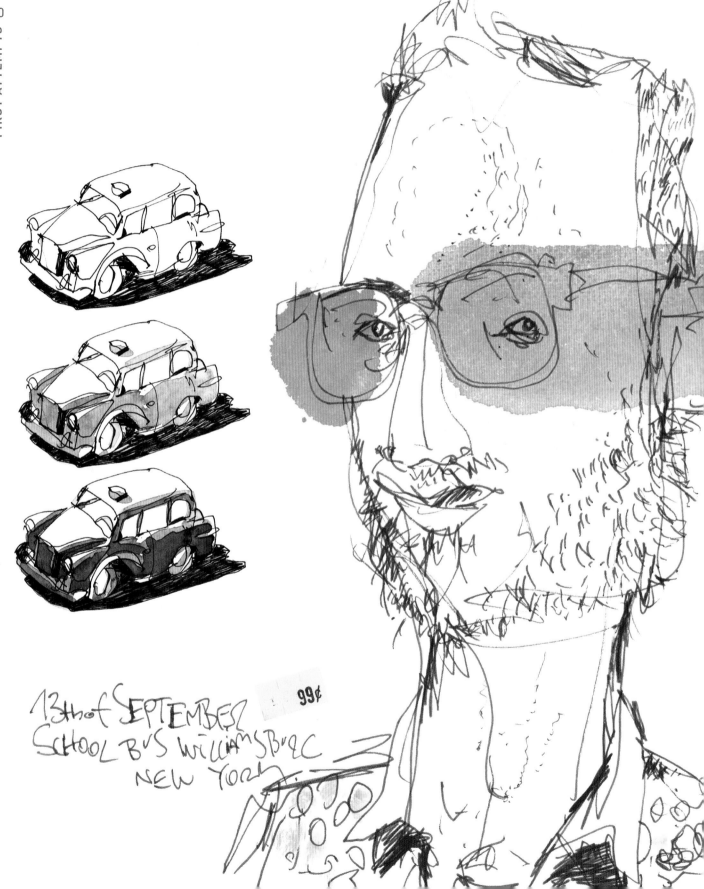

13th of SEPTEMBER
SCHOOL BUS WILLIAMSBURG
NEW YORK

99¢

LAYER
FOR LAYER
The Glaze

The examples of the car and the cube illustrate how the glaze is used. We leave the lightest layer white, paint the second-lightest layer, allow it to dry, and apply another layer over that to create darker areas.

1.

2.

3.

In simplest terms, a glaze can be compared to a pair of sunglasses in that it provides a darker layer over light. If you were to put one pair of sunglasses on over another, you would notice that things get a little darker with each pair. A glaze basically works the same way: we see our drawing (or parts of it) through a layer of color.

This is what makes watercolor so unique. With any other painting medium, the white space of the support is simply covered up by opaque mediums. In a watercolor painting or sketch, this white space plays an incredibly important—if not the decisive—role in glazing. This white space becomes the light in your picture, and what you paint is the shadow.

But, let's back up for a minute.

Since watercolors are somewhat translucent, we can see not only the white of the paper through each layer of paint, but also all of the underlying layers of color. And since each layer is like a colored film, multiple layers add up to darker and darker shades. When we paint the same color twice, one layer over another, this same color becomes darker. This effect intensifies with each new layer.

The school bus was also painted using two layers of yellow watercolor. A little blue was used for the windowpanes.

MIXING COLORS WITH GLAZES

In a nutshell, the main difference between ink and paint becomes obvious when we mix color.

When we put a number of layers of paint over one another, the color intensifies with each additional layer. This is also the case for ink.

Yet paint does far more: it blends with other colors. When we layer with the same color, of course that color will intensify with each new layer. But when you glaze using a number of different colors, they influence one another and visibly blend to create new hues. Ink does not blend like this and does not produce as successful results when used this way.

Glazing is the equivalent of Photoshop's multiply mode.

Just imagine if you were working with colored glass or colored transparencies. If you laid multiple colored transparencies on top of one another, the shades would not only get darker, as they do with ink. Their colors would blend. A blue layer and a yellow layer laid on top of each other behave the same as if you mixed the paints on the palette. They make green.

This makes working with watercolors a little tricky at first. You need to think not only in terms of values but also hues, taking into account that glazes blend on paper and create new colors. It is therefore wise to start with just a few related colors.

With a little practice, you'll quickly get the hang of it and will be able to conjure up new mixtures relatively quickly and easily.

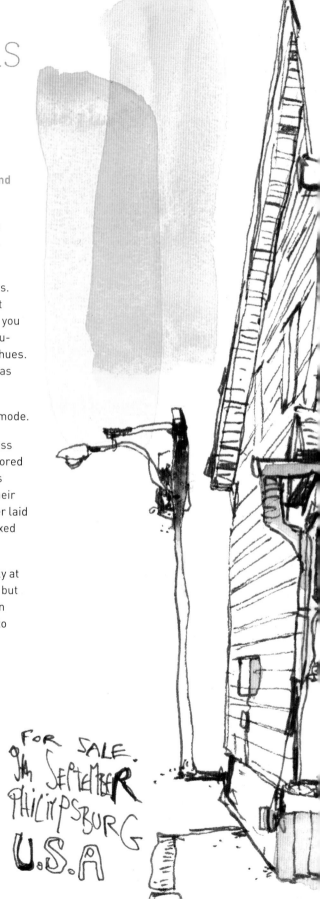

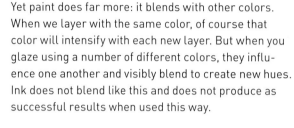

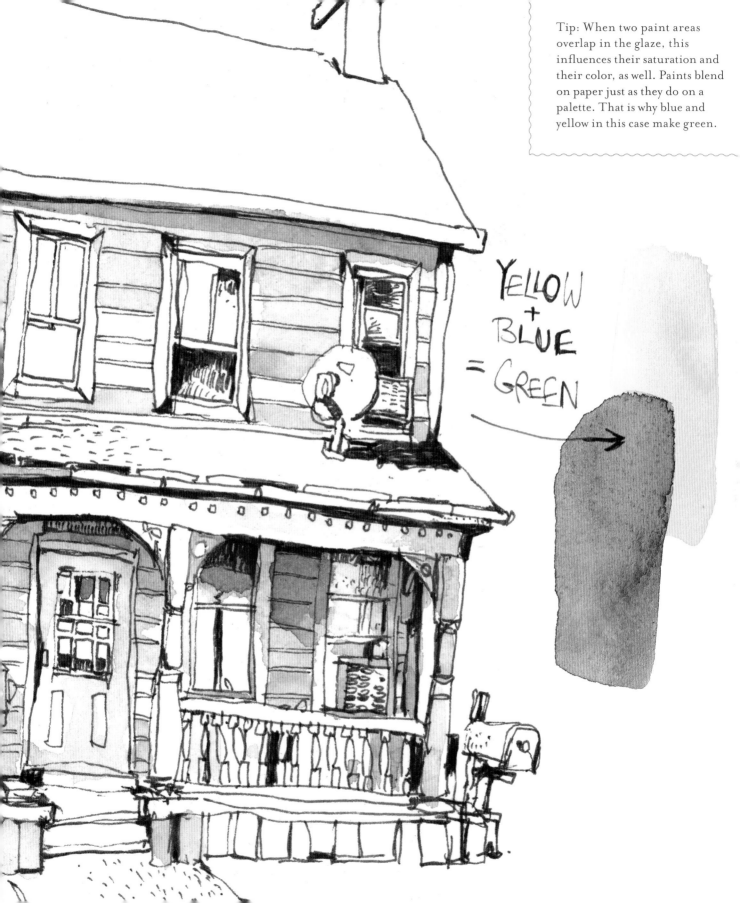

Tip: When two paint areas overlap in the glaze, this influences their saturation and their color, as well. Paints blend on paper just as they do on a palette. That is why blue and yellow in this case make green.

YELLOW
+
BLUE
= GREEN

FISH SOUP
Practicing the Glaze

One good glazing exercise is to paint your favorite food. There are foods in almost every color. The great thing about them is that their color spectrum looks natural and (hopefully) not like plastic. That makes painting your favorite dish the ideal exercise.

So, why not paint a recipe before cooking it? Paint the ingredients, paint the kitchen utensils, and paint the finished dish! Apply layer after layer to your drawings, which will cause them to develop further with each brushstroke.

You will be amazed at how many colors fish scales or the skin of an onion, for example, contain.

And when you paint your favorite dish, it's not just good for exercise in painting. It offers you a visual and a culinary pleasure.

Tip: In most cases, two to three layers are sufficient to achieve color and depth with a glaze. Remember to let each layer dry thoroughly before adding another.

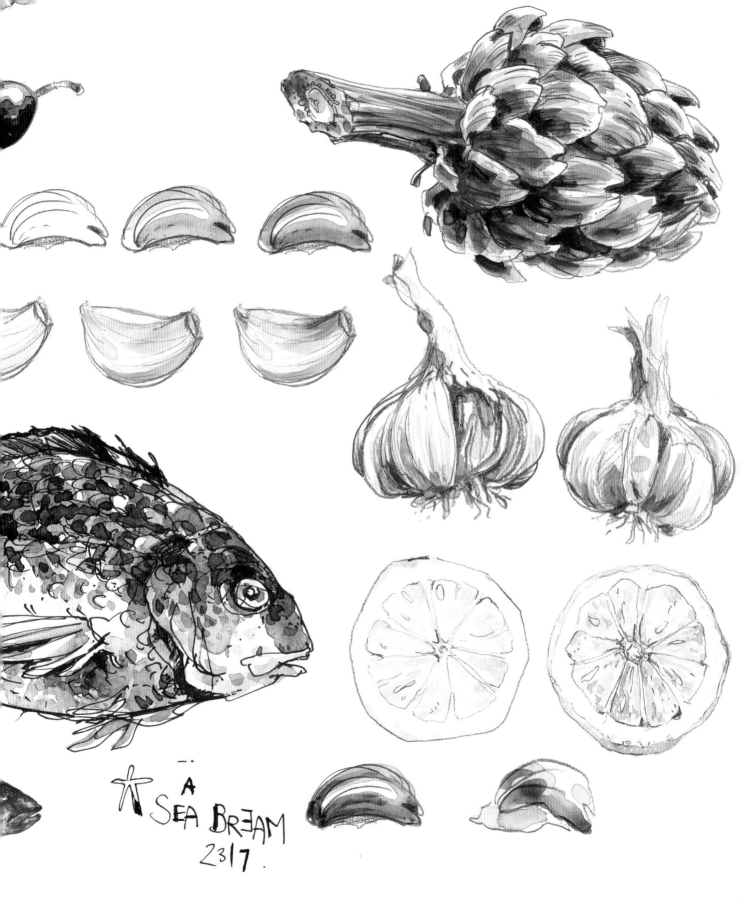

A
SEA BREAM
23|7 .

THE WASH
The Paint Does as It Pleases!

Splish-splash. Once you start using more and more water, things get really exciting. However, the difficulty with turning on the taps will become obvious after your first few strokes: you'll find that the paint does as it pleases. There is no way to control it, but it will open up a whole new world of possibilities to you, if you just let the paint paint.

There are two basic watercolor techniques: the glaze and the wash. All others techniques are basically combinations of these two.

Glazing, or applying the paint in layers, involves painting with control.

Washing works differently. Heavily diluted paint simply refuses to behave like a marker. It relies on coincidence. On one part of the picture it dries more quickly; another forms puddles. Just as the paint dries irregularly, so will irregular things happen in your sketch. However, what looks like an unsightly blotch of paint at first glance actually represents a beautiful characteristic of watercolor. When lots of water collects in one area and lots of paint in another, it creates a delicate, cloudy transition in color that you can use to your advantage.

In reality, this is closer to how we perceive light. It is not just there (or not there) like bulbs in our living rooms lamps; light offers subtle intermediates. Applying a wash keeps you from portraying what you see in stark, choppy gradations and allows you to lend it depth through intermingling.

So, don't be afraid of a little water.

H2O

Tip: Screw-top jars or cups are practical when you're on the go, like used jam jars or plastic vials from the pharmacy.

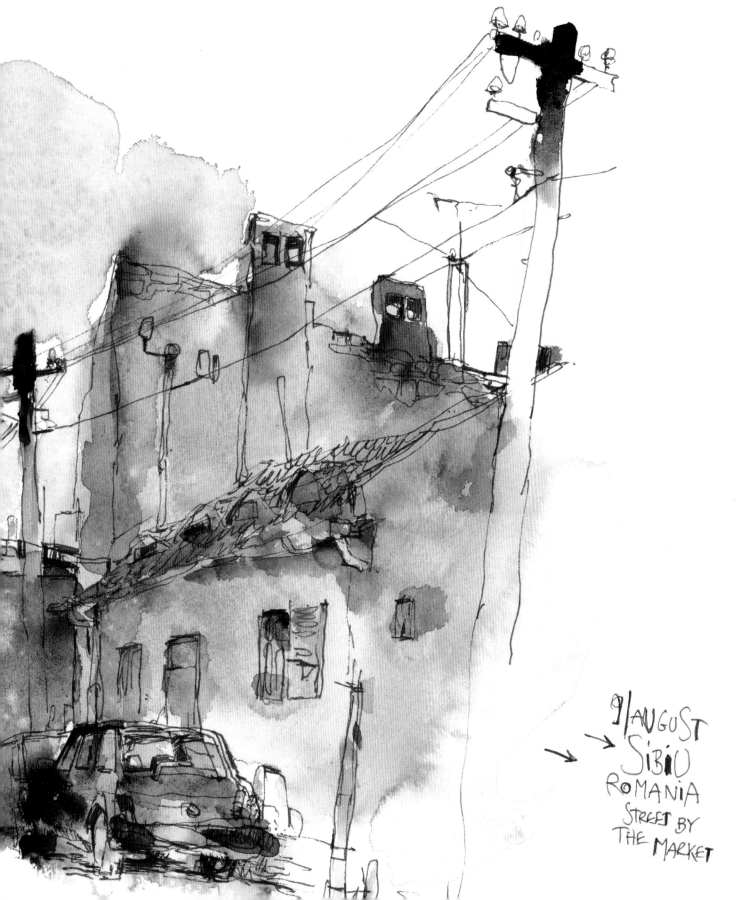

9/AUGUST
SIBIU
ROMANIA
STREET BY
THE MARKET

ON THE RUN
Graded Wash Techniques

DARE TO LET THE
PAINTS RUN TOGETHER.

GRADED WASH ★
TECHNIQUE

WASH:
STUDY OF A
DANCER.
to SEPARATE
THE COLORS
(e.g. BETWEEN
THE DRESS AND
HER SKIN),
A THIN WHITE
STRIPE is
"RESERVED".

* SARAH
DR
SKETCH
1/1/11

Wet paint behaves strangely. It doesn't just dry predictably like a marker does; it changes. Sometimes it contracts; sometimes it simply wanders off in its own direction. And it behaves peculiarly indeed when it meets more wet paint. Painted areas may flow into one another when they meet. The colors blend and form intermediate shades, create transitional zones and boundaries. In this sense, your colors can mix without a palette.

These tendencies are precisely what we rely on to create a graded wash in a picture.

Light creates depth because it does not reach all the parts of a room evenly. It illuminates the areas it hits, and the areas it doesn't reach remain dark. Between black and white it forms gradations of grays and colors. We try to mimic this in our paintings. We position certain colors near one another to create darker areas and—particularly with watercolors—allow the white of the paper to take on the role of lighter areas.

We saw in the previous chapter that we can use glazes to create nuances and transitions. Now, we will create intermediate hues by letting areas of paint run together. It doesn't matter whether we mix the paints or just lighten one area, perhaps with water. In either case, we rely on paint's tendency to actually move around the paper to create the transitions.

In practice, this means letting the painted areas run together carefully wherever we desire colors to blend (for example, to create depth with two shades). Conversely, in places where transitions would not be appropriate (like between the dancer's dress and her skin), we leave a little bit of white as a border.

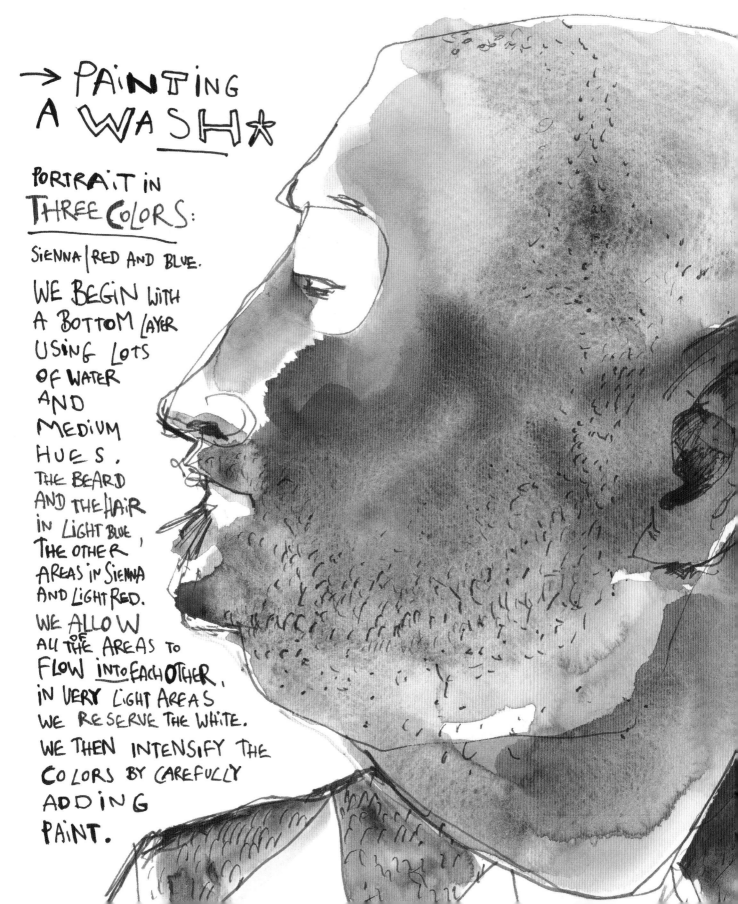

→ PAINTING
A WASH *

PORTRAIT IN
THREE COLORS:

SIENNA | RED AND BLUE.

WE BEGIN WITH
A BOTTOM LAYER
USING LOTS
OF WATER
AND
MEDIUM
HUES.
THE BEARD
AND THE HAIR
IN LIGHT BLUE,
THE OTHER
AREAS IN SIENNA
AND LIGHT RED.
WE ALLOW
ALL OF THE AREAS TO
FLOW INTO EACH OTHER.
IN VERY LIGHT AREAS
WE RESERVE THE WHITE.
WE THEN INTENSIFY THE
COLORS BY CAREFULLY
ADDING
PAINT.

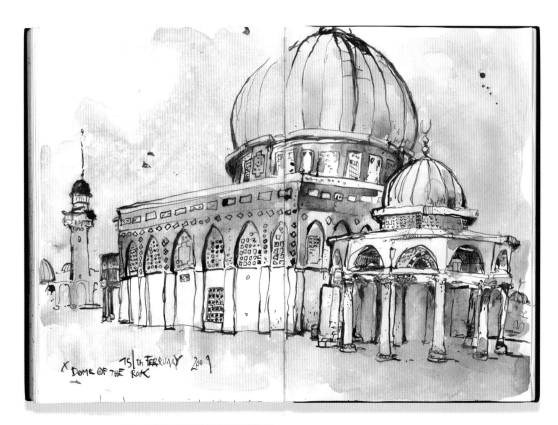

Wash techniques in the
sketchbook.
Above: Dome of the Rock,
Jerusalem.
Below: Zeche Zollverein,
Essen.

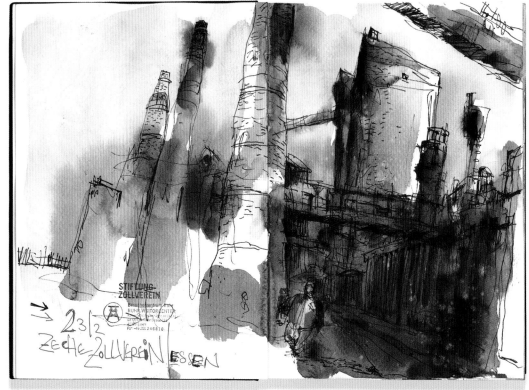

ONCE MORE, WITH FEELING!
Washes

Tip: Watercolor paint needs to be carefully diluted. It can't be too dry, but if it's too wet it is hard to control. In time you will develop a feel for the right amounts.

When you let the paints intermingle, the difficulty lies in achieving the correct ratio of water to paint.

"Easier said than done," you'll think.

I wish I could just give you a recipe for the perfect mixture of paint and water. Something like "take 2 tablespoons of water and 4 tablespoons of paint and whisk together on high speed for 15 minutes." Sadly, there is no such recipe.

Again, control is essential. Too much water is just as useless as too little. It's also no help if one color just washes away the other or swallows it.

You have to develop a feel for it. It's a combination of letting go and maintaining control. The easiest way to learn it is simply to try it again and again.

You can use a watercolor brush both to apply paint and to remove it. I usually have my brush in my right hand and a cloth or tissue in my left hand. Whenever I want to add paint, I mix it with water first. When I've used too much paint, I wipe my brush dry on the cloth and then use the brush to wick the excess paint from the paper. This works surprisingly well.

13th of SEPTEMBER
(A) TRAIN NYC.

IT'S A GIVE AND TAKE
Applying and Removing Paint

First, try intensifying a single area of paint. Dab a little wet paint on just one part of a brushstroke. You'll see: the color intensifies. If you think there's too much wet paint in one area, use your dry brush to remove a little bit. Observe what the paint does when you interfere with it this way, and let it surprise you. With every attempt, you learn a little more. Once you feel comfortable applying and carefully taking away paint with a dry brush, it's a tremendously fast and useful technique to have in your arsenal. Just a few strokes and you can achieve wonderful effects of color, texture, and depth.

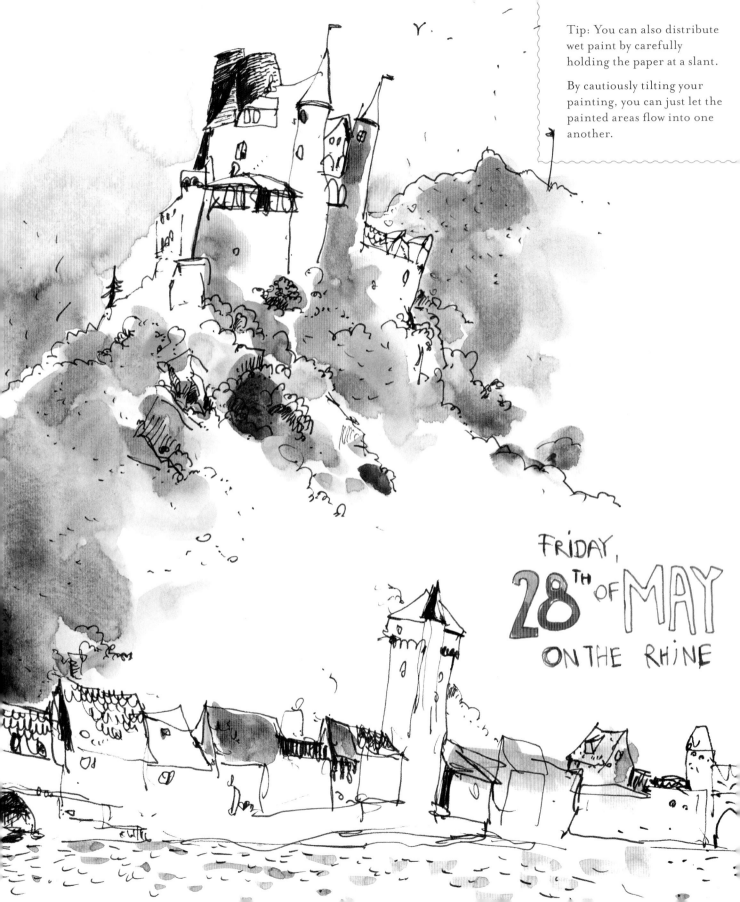

Tip: You can also distribute wet paint by carefully holding the paper at a slant.

By cautiously tilting your painting, you can just let the painted areas flow into one another.

FRIDAY,
28TH OF MAY
ON THE RHINE

WET-ON-WET

Taking the graded wash technique to the extreme is what we call wet-on-wet.

The method basically works exactly the way it sounds: wet paint is applied directly to a wet support. This technique is typically used for subjects that have blurry, fluid edges such as sky, clouds, air, and water. To be honest, wet-on-wet can quickly look pretty kitschy. But there is also some beauty in the vagueness of a wet-on-wet picture, as atmosphere, color, and mood cannot be conveyed as well with any other technique.

Clouds wet-on-wet.
Colors used: ultramarine and indigo for the sky, very diluted blend of umber and ultramarine for the shadows of the clouds.

For wet-on-wet, we completely wet our paper with water (you can tint the water with a bit of color for a base tone, if you like) and then apply the paint directly to the wet surface. This creates cloudy areas that require some practice to control and master. The paint spreads softly, and all of the transitions appear surprisingly natural. The main difficulty of wet-on-wet is clarifying all of the shapes' contours and making the wishy-washiness solid again.

How do we do this, then?

One way is to wait for the moment when the picture is just almost dry to solidify the shapes using your brush.

Another tried-and-true method is to leave little white pathways between areas of paint to keep them from converging. But the simplest way is to employ wet-on-wet during your picture's primary stages. You create a cloudy, vague atmosphere first with this technique, and then after it dries, you continue with the more specific aspects of your painting. Wet-on-wet will become a valued friend in your quest for better paintings.

Tip: With the wet-on-wet technique in particular, you'll notice that, when wet, the watercolor paint appears to glow far more. This is typical for watercolor paint. However, it will lose some of its intensity when it's dry. It's best to recognize this right away and use a little more paint from the start.

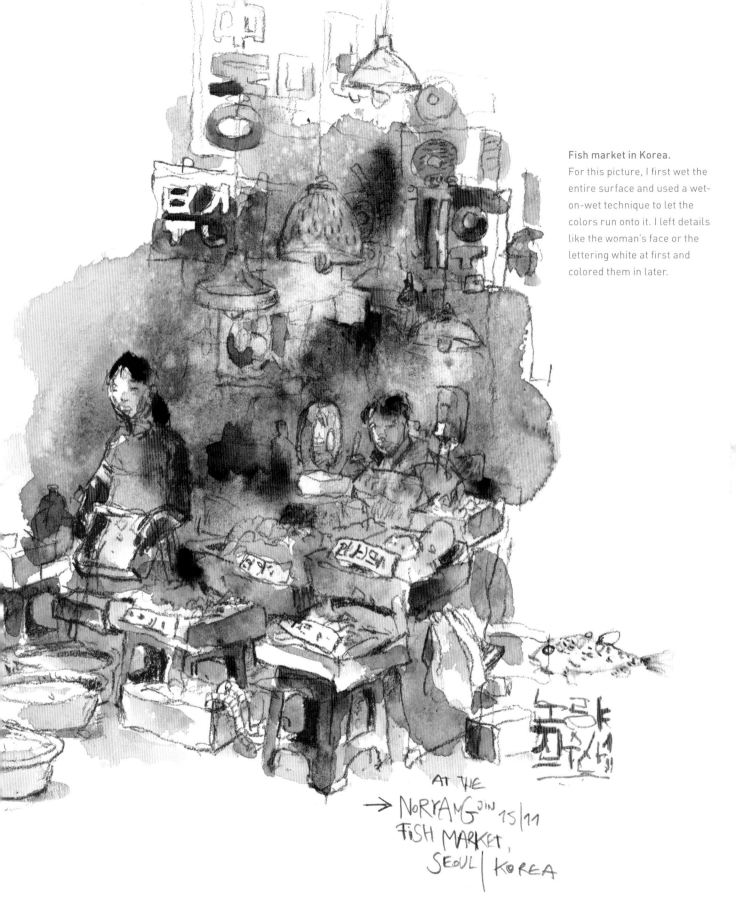

Fish market in Korea.
For this picture, I first wet the entire surface and used a wet-on-wet technique to let the colors run onto it. I left details like the woman's face or the lettering white at first and colored them in later.

AT THE
→ NORYANGJIN 15/11
FISH MARKET,
SEOUL | KOREA

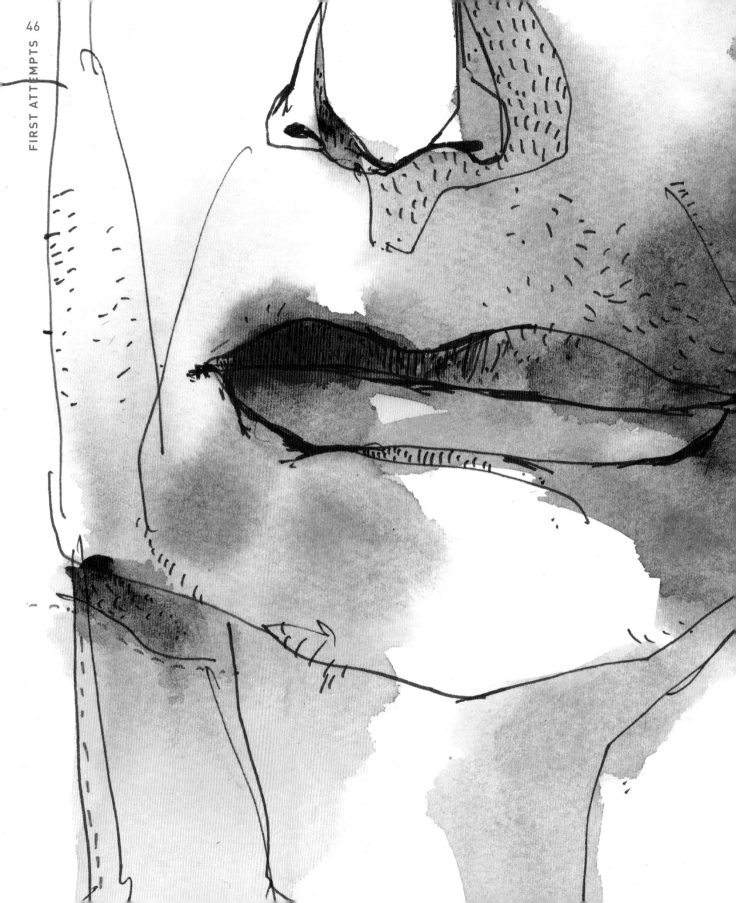

COMBINING TECHNIQUES
A Little Bit of This and That

Tip: Combine the wash and glaze techniques.

In the example on the left, a wash was applied and later accentuated with glazed elements.

If you only rely on these two main directions of water-color painting, you'll soon realize that one trumpeted technique on its own won't suffice. By now, you can probably ascertain that both the glaze and the wash have their advantages, but they do not offer the best solution for every painterly problem.

Washing is a fantastic means of creating transitions and forcing colors to mingle. But glazing is far more suited for marking off and treating specific areas or portraying textures.

What's to be done?

My solution is to throw the idea of "one technique only" overboard. You'll reach your goal much sooner by combining the two. So, my advice is to forget pure technique and try a little bit of this and that!

After it dries, a wash can usually stand up very well to another glazed layer. Adding a glaze elaborates and accentuates a subject. It also does your picture some good to allow the precise boundaries of the glazed layer to run into some neighboring, wet, washy areas every now and then.

It may seem unorthodox at first glance, but alternating between the two main techniques is what brings watercolors to life.

WHERE DO COLORS COME FROM?
The Simple Science

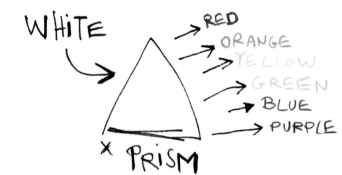

Colors can caress us or assault us. They can pile up to create sunsets or even jack up the price of a car. Colors are nothing less than wonderful, and yet the question of what colors actually are often remains unanswered.

What makes up the stuff that brings our world to life?

It's science. Sunlight, the by-product of a hydrogen fusion that occurs at tens of millions of degrees Fahrenheit, contains a mixture of electromagnetic waves. Sunlight first arrives here, just like heat or ultraviolet rays, as part of a wave of energy. The colors we see come from these electromagnetic waves. They are minuscule elements that dash through space as bits of a larger wave and that, upon meeting our eyes, trigger electrical signals in our optic nerves. But what determines each color? Why is an apple red? Why is the sea blue?

After its journey through space, the light arrives here as an energy wave with a visible and an invisible spectrum. The entire visible part of this wave appears white at first. Colors enter this spectrum when it meets a surface. It may meet a water molecule or a piece of carbon, or perhaps that apple. The light ray that was originally white is now either absorbed or reflected. Sometimes only parts of the light ray are thrown back. And those are the colors we see. When the ray of light is swallowed up entirely, the surfaces look black to us; when it is thrown back completely, the surfaces appear white. But when parts of the ray of light are reflected, we see a particular color. Every ray of light consists of all colors, which, all together, look white. When a surface swallows up all of the parts of an arriving ray and throws back, for instance, just the blue parts, we see blue. We only see the elements of the light ray that are not absorbed.

Therefore, colors depend on surface structures that absorb light rays differently. It may be hard to imagine, but everything around us is lit up by billions of tiny elements that hurtle through space and illuminate our world—or, to put it more poetically, that, depending on what they reach, burst into red, blue, or yellow.

It may sound like a platitude, but for a couple of reasons, there is a big difference between the colors we see and the colors we use to paint. This is another bit of physics: luminous color and nonluminous color, or surface color.

We can see that white light contains every color when, on its way through the clouds, it breaks to form a rainbow. Through this refraction, it transforms into every possible color.

LUMINOUS + LUMINOUS = **WHITE**
NON LUMINOUS + NON LUMINOUS = BLACK

But the reflection and absorption of light waves do not explain everything. In terms of physics, colored light and the colors we use for painting are very different things.

Mixing different colors of paint explains the difference. When you mix paints with one another, you will notice that every time you add a different hue, the mixture gets darker. The more colors you use, the more your result will look like a dark grayish-brown gravy (in reality, if you mixed all the paints in your box, you'd end up with almost black).

Strangely enough, colored light behaves exactly the other way around.

If you were to mix colored light, all the colors of the spectrum would ultimately unite to create white light.

This may sound odd, but it explains a great deal about the structure of colors. Light is energy. When you keep adding a different color of light, just as an illuminated room becomes brighter, the color spectrum becomes more complete, producing bright white.

As mentioned, it's the complete opposite for colors that consist of a substance—like an apple or the paints in our set. Their color is determined by the specific parts of the original light wave that are reflected. Remember, color is what's left over when part of the original ray is absorbed. When we mix paint, we are adding to the substance that absorbs the spectrum. This, of course, leads to even more of the spectrum being absorbed, which makes the colors darker.

Enough theory.

I'll let you in on a secret. The secret to understanding colors is not so much knowing about their structure or the way they come into this world. The secret to using color is to understand the way we perceive them and what they mean to us. Theory remains theoretical, but practice is colorful.

Tip: The difference between luminous and nonluminous colors is illustrated by printing. The blended colors on our screens are additive, or a blend of luminous colors. Colors printed or painted on paper are subtractive, or a blend of nonluminous colors.

Large detail: Color wheel
according to Goethe,
1809.

Inset: Newton's color
wheel from 1704.

ARRANGING COLORS

The first printed color wheel originated in England in the late Middle Ages. It was actually published in a medical textbook by Robert Fludd, who recommended using the color wheel to observe abnormalities in patients' urine.

We have the studies of Isaac Newton to thank for a true understanding of colors. Newton was the first to attribute color to light, and his color wheel from Opticks was published in 1704 (see opposite). He arranged the primary colors in a circle, placing the complementary colors between each primary, thereby inventing a very modern-looking color wheel—but it contained an asymmetrical seven colors.

By comparison, the often-cited symmetrical color wheel by Goethe represented six colors. All his life, Goethe, who, by the way, considered his work in natural sciences—not his poetry—his magnum opus, vehemently opposed Newton's teachings. He contested that colors are associated with emotional states ("Reason and goodness are yellow"), which, although an interesting body of thought, hasn't gained wide respect, since we perceive colors so subjectively. Newton was certainly on the right track with his purely scientific assessment of colors. Terms like *beauty* and *aesthetics* have a lot to do with the culture we live in. For example, our color of mourning is black, whereas in Japan, white is worn to symbolize loss.

So, why do we need a system for organizing color at all?

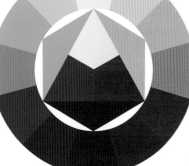

A look at your paint set will answer that question. Systems facilitate the work. The color wheel is a great aid. It offers a simple, easy-to-grasp system from which we can accurately derive color contrasts and color harmonies. For instance, complementary colors are always opposite each other on a color wheel.

In addition, most color harmony systems are also based on the color wheel.

The color wheel not only organizes, it also maps our human perception of colors.

The most useful color wheel for our purposes was influenced by the Bauhaus teacher Johannes Itten (see above). His model consists of the three primary colors of red, yellow, and blue, and their combinations (secondary colors) of orange, green, and purple. The outer ring also contains the combination of primary and secondary hues, called tertiary colors. For our work, however, the simplified model on the left here with six colors will do just fine.

We will come back to that later.

Above, left: Simplified color wheel made of primary and secondary colors.
Above, right: Itten's Color wheel. The primary colors are in the middle and next to them are the secondary colors surrounded by a circle of primary, secondary, and tertiary colors.

OPPOSITES ATTRACT
Color Contrasts

Tip: Complementary colors are those that we perceive as the most dissimilar, which is why they sit opposite one another in the color wheel.

Contrasts create differences that are highly noticeable—large and small, cool and warm, black and white.

So, what do contrasts have to do with painting? First of all, we can use them to create emphasis in our sketches. Think about it; a giant doesn't look "really big" until we place him next to a child. We can only produce a really dark night if it's paired with a starry sky. In

other words, we make use of opposing elements to make them intensify each other. For paints that are not very strongly pigmented, like watercolor paint, this is a good trick.

Complementary colors intensify each other. So, if we want to paint a strong orange-colored sunset, we simply need to add some complementary blue in the foreground shadows, and the orange begins to glow. Red strawberries look much fresher with green stems and leaves. And a tiny spot of purple considerably enhances a sketch dominated by yellows and oranges. When we put complementary colors next to each other, therefore, they intensify each other's hue and brilliance. Thus, contrasts serve not only to differentiate, but also to influence colors' effects in a sketch.

Having said this, directly mixing complementary colors together detracts from this illuminating effect. If we mix red and green, they turn into a dark brown; purple and yellow or blue and orange also result in grayish-brown tones. It's as if the intense effect of complementary colors is completely reversed once the hues are

mixed; as neighbors, complementary colors intensify each other. When mixed, they eliminate each other.

In color theory, there are seven types of contrasts, "the magnificent seven," which you can use to enhance and illuminate your sketches:

1. Light-dark contrast is the effect of contrasting brightnesses, especially for black, white, and grays.

2. Cool-warm contrast is the effect of contrasting warm and cool colors in the same composition.

3. Pure color contrast is the contrasting effect between pure colors that have not been mixed with others.

4. Quality contrast is the effect created by surfaces that are treated differently, for example luminous and clouded, saturated and unsaturated, defined and blurred, etc.

5. Quantity contrast is the opposition between colored surfaces of different sizes.

6. Simultaneous contrast is the reciprocal effect that adjacent colors have on each other.

7. Complementary contrast is the intensifying effect of complementary colors placed next to each other.

FROM SOUTH PARK TO STOPLIGHTS
Types of Color

When we talk about colors, it's worthwhile to first examine the ways we can use them. Basically, we differentiate between three basic types of color: local color, iconographic color, and true color.

First things first. Local color provides you with the simplest way to work. Local color creates a simple, graphic picture and is not gradated with any shadows that might create depth. Light and shadow are ignored. The grass is green and the sky is blue.

ASTERIX C. 1959

Comics typically make great use of local color. Scrooge McDuck's red jacket is just a flat red. It is not subject to light or shadow and is not modified in various different shades. Similarly, the rocket on Hergé's cover or the clothing on the South Park kids does not appear in different shades. The color of the object is simply transferred two-dimensionally to the picture, unchanged.

Using local color is a good way to work when we want to keep things simple but still create a dramatic effect, or when we just don't have the time to mix paints.

In terms of effort, local color gives you the most bang for your buck; it is simple but still conveys a high degree of accurate information about your subject's surface.

The second type of color, iconographic color, heads entirely in the other direction, unconcerned with a color's outward appearance. Instead, iconographic color taps into a hue's social significance (the Greek word *eikon* means picture, the word *graphein* means to write).

Iconographic color is an older principle that interestingly seems both archaic and modern from today's perspective.

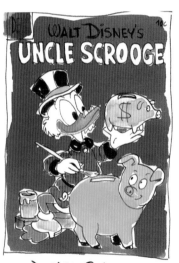

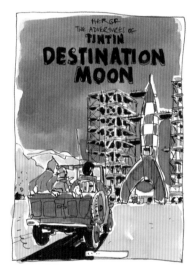

→ CARL BARKS AND HERGÉ FROM 1952

"THE MOUSE" FROM 1971

⇒ SOUTH PARK FROM 1997
LOCAL COLOR

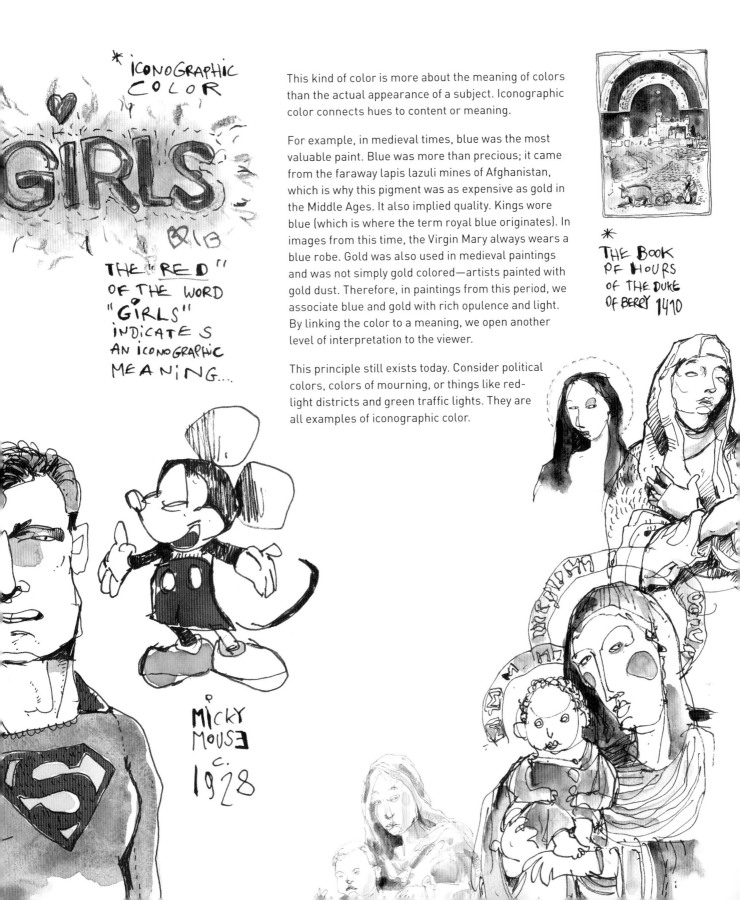

*** ICONOGRAPHIC COLOR**

THE "<u>RED</u>" OF THE WORD "GIRLS" INDICATES AN ICONOGRAPHIC MEANING....

This kind of color is more about the meaning of colors than the actual appearance of a subject. Iconographic color connects hues to content or meaning.

For example, in medieval times, blue was the most valuable paint. Blue was more than precious; it came from the faraway lapis lazuli mines of Afghanistan, which is why this pigment was as expensive as gold in the Middle Ages. It also implied quality. Kings wore blue (which is where the term royal blue originates). In images from this time, the Virgin Mary always wears a blue robe. Gold was also used in medieval paintings and was not simply gold colored—artists painted with gold dust. Therefore, in paintings from this period, we associate blue and gold with rich opulence and light. By linking the color to a meaning, we open another level of interpretation to the viewer.

This principle still exists today. Consider political colors, colors of mourning, or things like red-light districts and green traffic lights. They are all examples of iconographic color.

*** THE BOOK OF HOURS OF THE DUKE OF BERRY 1410**

MICKY MOUSE C. 1928

TRUE COLOR
The Effect of Light

Things get more complicated with true color. We use true color when we paint "properly," or attempt to portray reality as it appears. Colors here are not merely flat areas; they are subject to the influence of the light. Basically, all painting since the Renaissance has aimed to capture the illusion of light and space, making use of true color.

The painting *Girl with a Pearl Earring*, below, is a classic example of this. It demonstrates the influence of light on color, and the artist's the true impression of each.

True color sounds simple at first, but it can be subjective, since we all have a very clear idea of how things should look.

And as odd as it sounds, how we think things should look often has very little to do with reality.

It is clear to us that a tomato is red and that it has a green stem, and we actually risk painting it just that way. If we do so, it will end up looking like plastic. All too often we paint things only as we imagine them to be and not as we experience them from observation. Learning to see as a painter is a terrific start. True color forces us to look. In reality, colors are not flat, delineated fields as they are when we use local color. If you look carefully, you will ascertain that the way a color looks really depends on the interplay of light and shadow. The red of the tomato is not just red. Perhaps the skin of the tomato tends a little toward purple in the shadow area, and perhaps the green of the stem is not just grass green but rather reflects the other colors around it. Color contrasts in particular don't look like cutouts from disparate sources. In reality, they work together. If you add these observations of reality to your pictures, they will begin to have a life of their own and seem believable and harmonious. Of course, paintings are not photographs . . .

Deceptively realistic portraits are generally created from studies of real models and not the imagination. Adhering to this practice teaches us to observe and see.

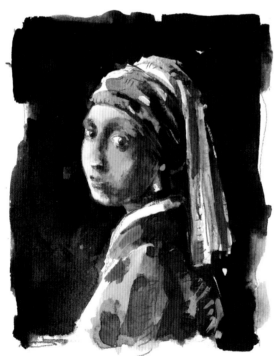

VERMEER TRUE COLOR OF 1665

GATE AT
GYEONGBOK GUNG
PALACE
SEOUL
KOREA

13th of NOVEMBER

Example of true color.
The colors are approached as they are seen.

RED.

RED.
RED.
RED
RED

* NEW YORK
FASHION
WEEK
24/9/10

EVERY COLOR
TELLS A STORY
Intensifying Your Sketches

Let's face it. No one can force you to apply colors to a sketch exactly the way you see them.

This is one of the advantages of painting over photography. Of course, you'll want to to give the formal elements of your picture a little boost. But then again, everything that you portray is more than its outward form, its surface. Every chair can tell a story, every landscape can convey a mood. So, it makes sense to intensify narrative components of a picture, and color is a great place to start.

Allow the colors to tell us something. In reality, the woman in the example on the left probably did not have such blazing red hair, and the man drinking in the sketchbook on the right probably did not have such a red mouth. But in art that is not the issue. Even if the color in a subject is not really as bright red as it seems, exaggerating your perception may help to convey it. It's merely a question of what it means to you. Perhaps intensifying a color makes sense in your sketch and tells a visual truth that a photograph wouldn't have been able to convey.

Your sketch is made solely from fragments that remain from your impressions.

Exact, verifiable "reality" does not exist for even one bat of an eye.

When you head home, the bird will have flown away, the light will have changed, and no one will reappear to check how red the red really was. What matters is how you perceive it. If you want to measure, weigh, or count, then art is not the right medium for you anyway.

So grasp the moment before it flies away, taking all its colors with it.

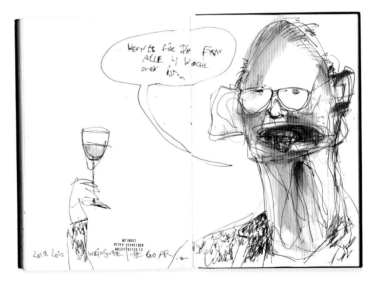

A page from my sketchbook drawn in the wee hours at a wine bar. Even if the man did not have such a red complexion in reality, it makes narrative sense to describe it this way in the picture.

IT'S ALL RELATIVE
The Effects of Colors

If I were to ask you to paint passion, emotion, and warmth, you would probably create a picture dominated by red. Red stands for feeling and warmth. Red is the color of love. Strangely enough, though, you would probably believe me if I also told you that red can symbolize hate, violence, and aggression.

A contradiction?

The same goes for green. Of course, green stands for hope, harmony, and reliance. Green is generally considered the color of spring and rejuvenation. On the other hand, poison is usually depicted as green, as are inexperience or naïveté. Let's take blue: clarity, loyalty, but also depression?

Upon close inspection, all that we thought we had learned about color becomes paradoxical. Why can certain colors simultaneously evoke starkly opposite feelings?

The answer actually lies in the other colors in a composition. Whether red is aggressive or green is hopeful is not a question of those hues alone. Colors may have effects on their own, but their surrounding colors strongly influence how we perceive them, too. So, whether red is aggressive or not depends chiefly on what accompanies it. Next to pink, for instance, red smiles at us in a friendly way. But next to black it hits us hard.

Our evolutionary history may offer one possible explanation for this. By nature, we are not really programmed to perceive colors in isolation because they practically never occur in nature on their own. They are almost always incorporated in complex relationships. The red, for example, of a cherry on a cherry tree is connected to the green of the leaves or the brown of the tree trunk. Whether red appears as blood in a wound or as the red of a flame in the fire, a color's environment is always different. Hence, depending on context, a hue can signal positive or negative associations. This is also what always makes looking at individual colors strangely abstract. When colors are detached and removed from others, they become a blank canvas for our thoughts and can invoke any kind of feeling in us. By contrast, if colors are interwoven with hues or images, they connote associations. Color relationships substantiate things in a picture.

This explains why red can mean love as well as hate—enough reason for us to take a closer look at color contexts.

No one, not even color, is an island.

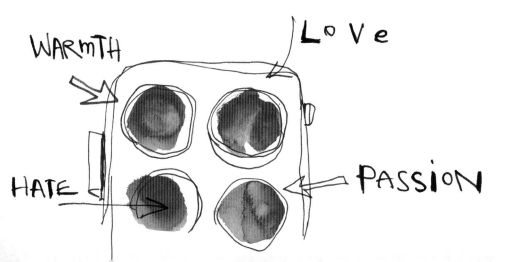

WARMTH

LoVe

HATE

PASSioN

Tip: The perception of beauty—and of beautiful color contexts—is also linked to culture. In Asia or India, very different color compositions are considered beautiful than, say, in Scandinavia. Color always depends on the individual within a greater cultural context.

COLOR HARMONIES
Simple and Complex

So, what colors go together? As it does for all of life's burning questions, the Internet has an astonishingly simple answer: color generators. On some sites, you can enter certain colors and a program generates the colors to go with them. Looks good and works fine.

Basically, I can quit writing.

If we are only working with color on a computer monitor, these generators really do work, as do mixing tables or using color wheels.

In real life, though, for real pictures, these only aid us. Paintings are not a matter of just composing a few, calculated color areas; rather, they involve complex color systems.

You'll notice this right away while sketching. Your picture changes with every brushstroke. For instance, when you apply a second color next to one that's already there, the effect of the first changes immediately. Related colors calm one another; complementary colors intensify each other.

Things such as color intensity and the size of a color area play a major role in painting.

In a nutshell, when painting, you'll deal with complex color systems to which digital tools can only briefly introduce us.

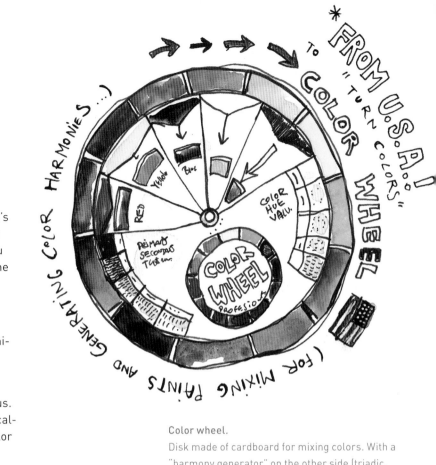

Color wheel.
Disk made of cardboard for mixing colors. With a "harmony generator" on the other side (triadic, tetradic, and split-complementary).

In spite of all this theory, I like to think of color as a feeling. The world is not made up of flat surfaces, blueprints, and calculated mechanical sketches; it is made up of odors, sounds, textures, and flavors.

The world is made up of light and of color.

Therefore, let's first take a look at color harmonies, starting with those most frequently encountered in painting.

Internet color generator (monochromatic).

YEil-
SEOU
KO

ANALOGOUS, MONOCHROMATIC, AND COMPLEMENTARY HARMONIES

The easiest way to create harmonious colors in a composition is simple and ingenious: use as few colors as possible. You can't make mistakes with just one color. For example, you can combine a lighter or darker hue with your main color.

This creates monochromatic harmony.

I can guarantee you that this almost always produces harmonious colors. I can also guarantee that this almost always looks very unspectacular. Monochromatic pictures usually look like they were painted in the fog.

It will certainly make it more interesting if you combine your one main color with two or three neighboring colors that are next to one another on the color wheel. These are called analogous harmonies. When one of these hues dominates slightly over the others, this combination very soon appears harmonious.

But you needn't only position relatives for a lovely family portrait. Opposites can also look good. If you use complementary colors in different proportions (like a small red ladybug on a big green leaf), the effect can appear harmonious. Transitioning between complementary hues also produces harmonies (seen in the example at left, the darkness separates the complementary colors blue and orange).

It may be a bit tricky to wrap your head around complementary harmonies, but their effect is surprising and enchanting.

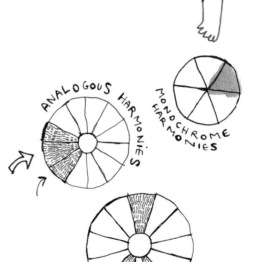

1219
MAYA SCULPTURE
LATE CLASSIC
PERIOD
MUSEUM OF
NATURAL
HISTORY
NEW YORK

The coloration of the Maya statue includes just one hue. That is why we call it a monochromatic harmony.

ANALOGOUS HARMONIES

MONOCHROME HARMONIES

SPLIT-COMPLEMENTARY HARMONIES (Y-AXIS)

SPLIT SPLIT

Tip: One variation on complementary harmony is split-complementary harmony. Instead of relying on a color's complement, split-complementary systems use the colors to the right and left of the complementary color (as they appear on a color wheel). For example, a split-complement triad could be green with red-orange and red-purple.

TRIADIC AND TETRADIC HARMONIES

The ominous-sounding words *triadic* and *tetradic* only mean that the colors involved are at even intervals from one another on the color wheel. Triadic harmonies involve three colors, and tetradic harmonies involve four.

Just imagine a triangle or a square in the middle of the twelve-color wheel (which includes the primary, secondary, and tertiary colors). Each corner or point would lie on colors that are harmonious with one another.

In practice, this simply means that colors that are all spaced the same distance from one another on the twelve-color wheel result in more harmonious color spectrums than those arranged at different distances from one another.

One more thing:

In spite of all of this color theory, there are always things that easily fit into any scheme. Even garish colors can look gorgeous in triadic, tetradic, and analogous harmonies.

In my opinion, a lot of this is simply a matter of taste and depends on what and how we paint. Perhaps a gaudily colored page of butterflies is beautiful and harmonious simply because butterflies happen to be beautiful and harmonious subjects, no matter what color we paint them.

So don't always play by the rules. If you head out on the road equipped only with color tools and mixing wheels, you might miss some really beautiful sights.

BLUE-PURPLE · RED-ORANGE · YELLOW-GREEN

PURPLE · ORANGE · GREEN

MAUVE · YELLOW-ORANGE · BLUE-GREEN

BLUE · RED · YELLOW

* TRIADIC HARMONIES

Tip: One rule of thumb is that if two colors produce a dull brown or gray color when mixed, it's actually likely that they harmonize quite well when separate.

COOL-COOL AND WARM-WARM HARMONIES

The terms *cool colors* **and** *warm colors* **are somewhat misleading.** Of course, such colors are not actually cool or warm to the touch; they just seem that way to us. However, studies have shown that rooms painted with red or orange hues actually feel a few degrees warmer to people than white rooms do. Likewise, in blue or green surroundings we tend to feel colder regardless of the actual room temperature.

This reaction is, again, probably a result of our evolutionary process, passed down to us by our ancestors sitting by the fire: Colors that remind us of sources of heat simply seem warmer to us. Colors that remind us of snow, water, or rain seem cool. This applies primarily to the colors themselves: red, orange, and yellow have a warmer effect on us per se. There are also colors within each family that have either a cooler or warmer effect. There are blues that appear warmer

(for example, red-tinged ultramarine) and blues that appear cooler (for example, blue shades that shimmer turquoise).

When you buy a set of watercolors they are already arranged in cool and warm hues. There is usually a cool and a warm representative of each color.

We often take advantage of the warm and the cool effects of colors when we want to create a specific mood in our pictures. Obviously, we tend to choose warm colors to create a friendly, cozy atmosphere. Or, for instance, if we need a crisp or subdued mood, we might use cooler colors.

Keep this simple rule in mind: Cool colors always look harmonious when combined with other cools. Warm colors are harmonious with other warms.

30th MAY
ISTANBUL

COLLECTING COLORS

Color harmonies can not only be studied as an aspect of color theory, but can also be found by the wayside. It's a little like the way Jack accidentally discovers a giant's house in the sky (not to mention his riches) in *Jack and the Beanstalk*.

Watercolors can easily be used to sketch color harmonies, and you will discover combinations almost everywhere that are worth saving. Just like the sketches in your sketchbooks, these can later be developed further in other works. Keep a stock of potential color combinations that you like in your sketchbook, and try recycling some in new pictures and sketches.

I think of it like remembering the melody (or a chord) from a certain song and playing it later with new lyrics (there's a reason they are called color "harmonies").

So, go get 'em. Finding beautiful, exciting combinations is free of charge. You simply have to open your eyes.

Tip: Of course, you can also collect color harmonies from magazines, photographs, or paintings. When they are taken out of context, something completely new will become of them!

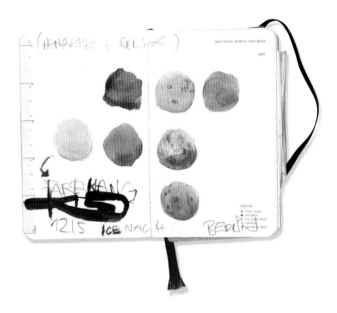

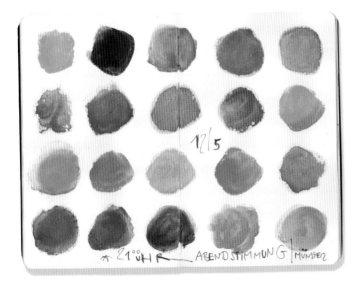

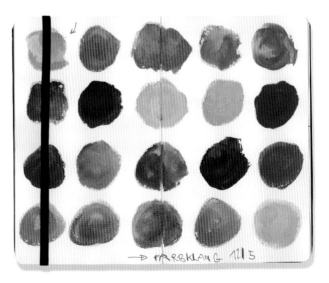

DESIGNING COLOR HARMONIES
Working with Color Code Strips

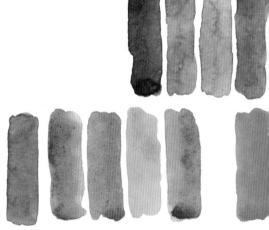

Of course, you can also invent your own color harmonies. Color codes give you a snapshot of a color scheme for quick reference. These are extremely useful and are often used in film production (for instance, to test the effect of a set's color scheme in advance). Color codes are columns of adjacent brushstrokes, each representing a different color in your overall scheme.

Especially when you are planning a painting, a design, or an illustration, it is helpful to have taken notes of colors so that you don't have to design the color schemes directly on the preparatory drawing. Instead, try "rehearsing" your picture first.

→ COLOR HARMONY

Begin with a few strips of the colors that you definitely plan to use, and then gradually add other colors that you think are harmonious. It's best to use two sheets of paper: one sheet of scratch paper for mixing colors and trying things out, and one for your color codes. The harmony produced can then serve as the model for your actual picture.

The color-code-strip technique not only allows you to test the color combinations in advance, but it also lets you determine how much of each color will appear in a picture. A few more strips of the same color in your color code simply implies larger color areas in your later picture.

You'll realize just how precious scrap paper is when you start creating color codes.

Tip: The advantage of color codes, or "color barcodes," is that you can see, in advance, which colors harmonize next to one another and which are dissonant.

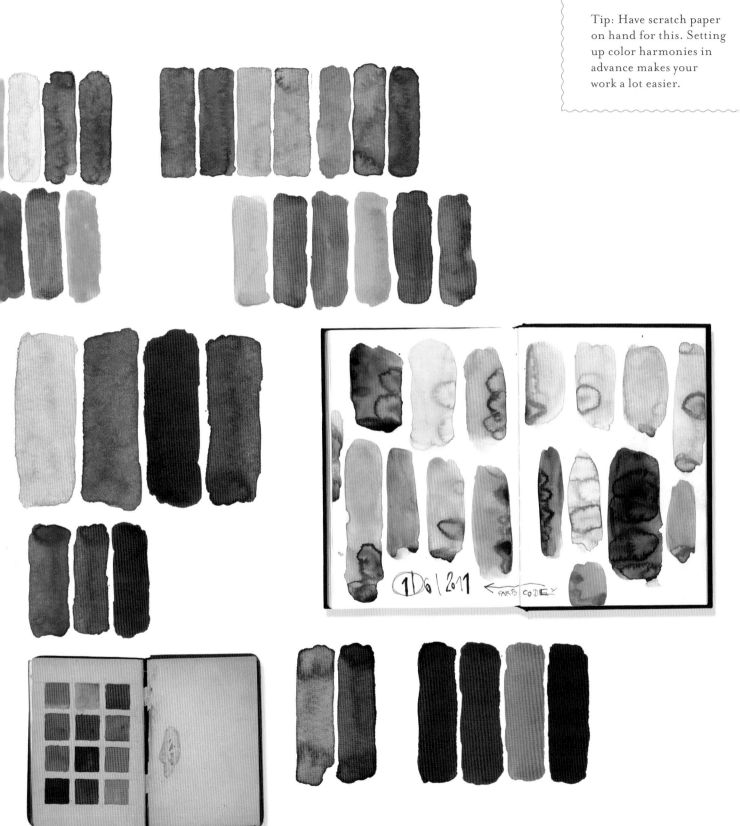

Tip: Have scratch paper on hand for this. Setting up color harmonies in advance makes your work a lot easier.

GETTING OUT OF YOUR COLOR COMFORT ZONE

Just like having favorite music or a favorite food, we all also have favorite colors that we like to use again and again. I, for example, love indigo; I like Naples yellow, red, mountain blue, and turquoise.

Having favorite colors and color harmonies is natural; all artists have their own personal palettes. Just take a look in your box: Which paints do you always have to replace and which ones last forever? Favorite colors are the ones whose trays or tubes are always empty.

On one hand, color preference is a matter of taste, but it also has something to do with comfort: we feel at ease with familiar colors. And, the thing about comfort zones is that we don't like to leave them. Because of this, "elsewhere" remains unexplored to us, and we don't try to visit it more frequently.

Comfort zones are understandable but dangerous to artists. If we take a look around, of course we realize that other, unfamiliar combinations of colors also look magnificent.

My advice is for you to deliberately take a detour now and then from the high road of your favorite colors and try the back roads. Allow fashion, films, or magazines to lend you new ideas; take a look at the color harmonies of other artists or borrow some from nature.

You'll see that unfamiliar color harmonies can be inspiring and open up new vistas to you.

If you get really stuck, simply swapping paint sets with someone can be a great experience!

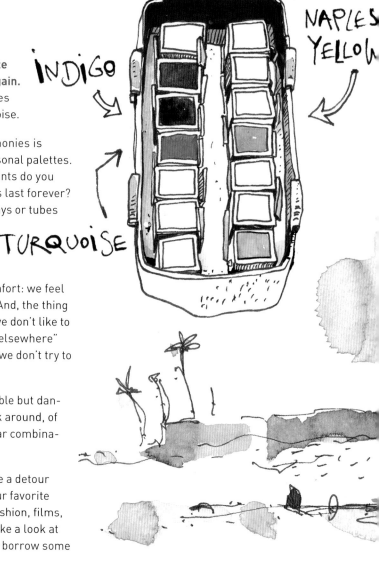

INDIGO

NAPLES YELLOW

TURQUOISE

I painted this beach
scene with another
artist's watercolors
and, therefore, her
color palette.

10|4
DELPHINARIUM | tEL AViV

THE BLUE RIDGE MOUNTAINS
Color and Perspective

How do you portray something far away? How about something up close?

Forget linear perspective; color also offers us an opportunity to convey distance.

Take the example of the Blue Ridge Mountains in the Appalachians or the Blue Mountains of New South Wales, or any number of ranges around the world that are called "blue" mountains. Technically speaking, they should be called the Pale Blue Mountains. You've probably seen pictures of them: a mountain chain in the background, far away, blurred, blue, and softly offsetting the clear contours in the foreground. Why do they look like that? Aren't the slopes themselves brown and green?

Physics offers the explanation. As we discussed earlier, light is a blend of electromagnetic waves that range from long-waved red to the shorter waves of blue and purple. In other words, colors that look warmer to us have longer waves, and cooler colors have shorter rays. Air and the particles in air scatter shorter wavelengths better than longer wavelengths. So, when a ray of light meets our eyes from afar—for example, from a mountain range in the distance—the shorter wavelengths are what reach us. As a result, the mountains look blue from a distance. At the same time, the intensity of the light rays decreases with distance. On its way to us, the light passes through ever-thicker layers of air, which reduce the rays' intensity. This causes the

Sketchbook from France, Côte d'Azur.
The mountains of the coastline appear pale blue from a distance.

* 4th ot AUGUST/10
FARM IN THE RAIN
BURGBERG
TRANSYLVANIA
ROMANIA

colors to look pale. We can make wonderful use of this effect to portray distances: The farther something is from us, the smaller, paler, and bluer we should paint it. Warm colors come to the foreground, and cool colors recede into the background.

Additionally, layers of air cause more distant objects to blur. Subjects that are far away lose both their distinct contours and their contrast. While close things contain a spectrum of contrasts ranging from very bright to very dark and everything in between, things that are far away are left with only the in-between. The midtone. Therefore, objects in the foreground are focused and sharp, and objects in the background are more blurred.

This is particularly beneficial to watercolor painting, because it is quite easy for us to portray paleness and blurriness if we use lots of water. To depict the distance of a mountain chain, we only have to apply a shade of blue to the paper using the wet-on-wet technique. The blurriness of the wet-on-wet and the specific shade of the blue produce a fantastic illusion of depth.

The mountains should actually be called the "small, blurry, low-contrast, cool, pale blue mountains." But that's easier to paint than to fit on a map.

The mountains on the horizon appear blue in the distance, although in reality, their dominant colors are green or brown.

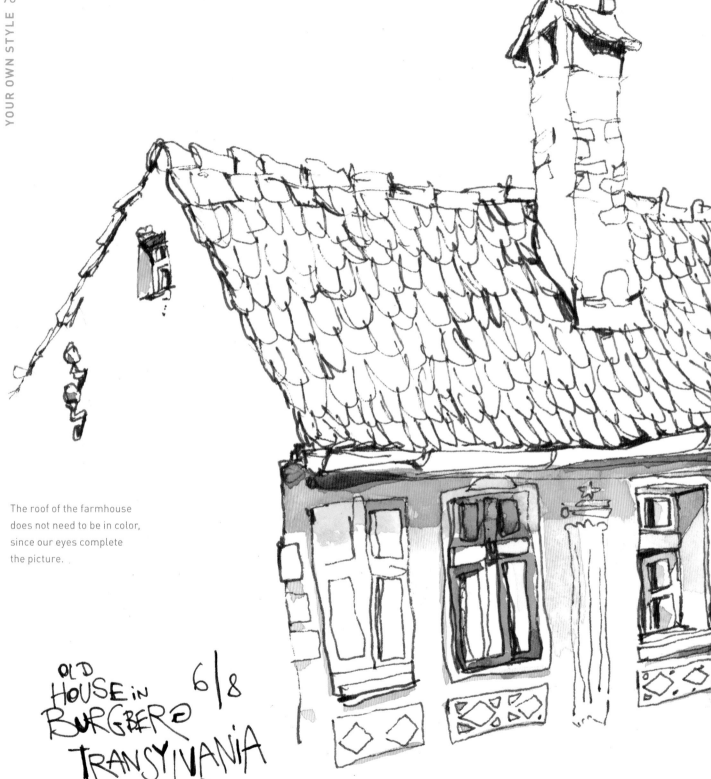

The roof of the farmhouse does not need to be in color, since our eyes complete the picture.

OLD HOUSE in BURGBERG 6/8 TRANSYLVANIA ROMANIA

LESS IS MORE

Be economical with colors. You will often achieve a far greater effect with watercolors if you do not paint every empty space in your picture. Try to reduce your painted areas and leave some parts untouched.

Make use of the white of the paper as an element. If you dare to leave the areas onto which the light falls white and instead only use color in the shadows, your eyes will automatically understand the picture. Keep this advice in mind—the white areas of the painting will become light-suffused, reflective areas that accentuate your colored shadows all the more.

You'll see: Less is more!

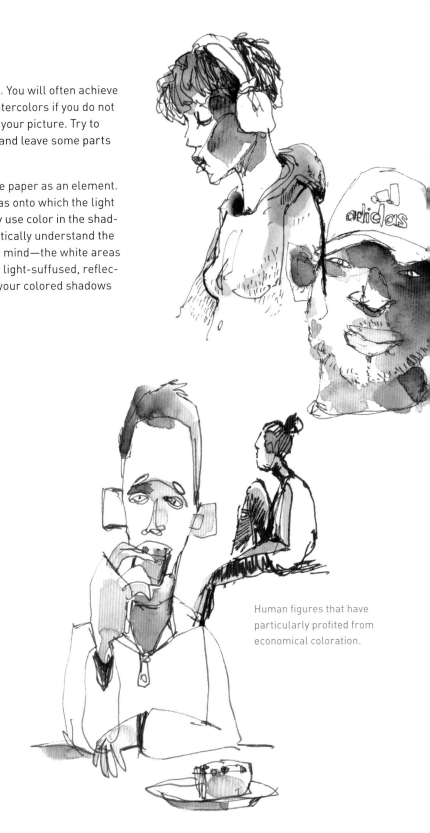

Human figures that have particularly profited from economical coloration.

ME, MYSELF, AND I
Finding Your Own Style

One of the most common considerations for artists is developing an unmistakable style. Yet the words, "That somehow reminds me of so-and-so . . ." can be an artistic death sentence.

We all have the need to be unique and distinctive.

What's all this about anyway? To be something new, to be noticed, to rise above the crowd? Is it about a market niche? Is it about immortality?

It is rather strange that we all have the feeling that as soon as a new movement or a new wave comes along, everything that came before it is obsolete or that every artistic novelty automatically supplants everything prior to it.

For example, when the CD was developed, there was immediately a debate about whether it was time to dispose of record players. When e-books came out, everyone worried that print books would disappear.

Our society values progress very highly, and people have set the bar very high throughout history; the printing press and penicillin were invented in Europe, and the artificial heart and the airplane were invented in America. In addition to this, we think in terms of individual success. We trace every single development back to an originator. Columbus discovered America, and Newton discovered gravity. It's just an easier way of thinking.

Art in particular is usually more complicated than that. Movements are often developed by a number of artists working together. Cultural accomplishments build upon one another. New pathways can even be opened up through apparent setbacks or intermediate steps.

So, don't make such a big deal of it all. Ultimately, you just want to paint, not invent steam engines. Let yourself be inspired by others (which is not the same as copying) and evolve further from there. Always attempt to broaden your own horizons. Talk with other painters, learn about movements, and visit art and design exhibitions. All of this will influence your own style.

And one more secret: You will probably be the last to recognize your own "unmistakable style," simply because it is so difficult for us to distance ourselves from our work. But ultimately you'll find that your style is just as unmistakable as you are.

Focus on substance! Whatever is new and modern now will still age. Substance never fades.

ZEICHNEN

WHEN ITS DARKNESS
ON THE DELTA THAT'S
THE TIME
MY
HEART
IS LIGHT

→ ALL GOD'S
GOT

THE MISSISIPI

MARCH 1973 ←

STYLE AND CREATIVITY

Another remark on the subject: your personal style grows on its own; it should not become a straitjacket.

As strange as it sounds, "your own style" and "creativity" are often opposing principles.

An artist is expected to be creative, to come up with new ideas and take new pathways. Strangely enough, we also expect artists to be recognizable. They should be both innovative and have a unique style. This facilitates classification of art throughout history and represents how the art market works.

In short, artist A is expected to be instantly distinguishable from artist B. People expect Picasso to paint something that looks like "a Picasso." And this creates a trap: innovating while complying with everyone's aesthetic expectations has very little to do with creative processes.

Creativity is unpredictable—after all, we're making something new.

Hence, the ambition to always create something new, while at the same time changing nothing whatsoever is simply nonsense. Niches like this may benefit art critics, but they inhibit creativity.

The point of innovation and inspiration is to not know beforehand what the result will be (some Dylan fans still resent today that he didn't stop trying new things in 1967).

You should paint pictures because you want to paint them, not because everyone wants you to paint them.

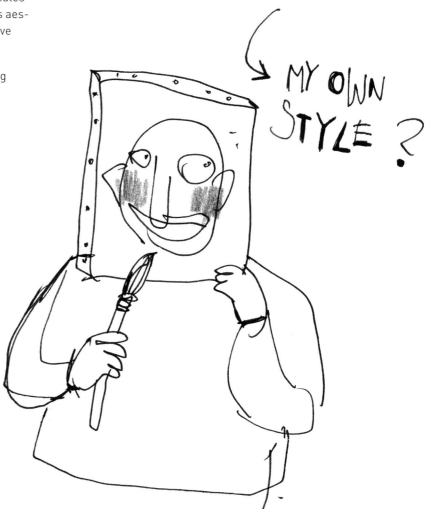

MY OWN STYLE ?

THROWING DOWN
Loosening Up Your Painting

"Ah, loosen up!" is an incredibly stupid command. A conscious effort to be relaxed and natural usually leads to the exact opposite. Expectations make us tense up. You can't be casual at will. The idea of fulfilling someone else's desire or a demand we make of ourselves kills even the slightest spark of creativity.

Advising painters to just throw down some paint, to develop a loose line, demonstrates a colossal lack of understanding of human nature. We only loosen up when we know something isn't important. As soon as we want to live up to expectations, things become important.

Of course, it still makes sense to use watercolors with ease and spontaneity. A good part of this is due to the nature of the medium itself. Watercolor paint appears at its most luminous if we don't spend a lot of time painting but just quickly throw it on the paper. Every time we paint a new layer or re-wet it a bit more, the picture becomes a little less vibrant.

Yet, knowing this, of course, does not make things easier. It makes every stroke carry incredible pressure: No mistakes now, concentrate, concentrate, I gotta, I gotta, I gotta . . . It's a true dilemma.

So, try to put a little distance between yourself and your expectations. Outwit yourself. This is why you should attempt to paint your pictures in sketchbooks or on plain paper rather than on giant six-foot panels. Battling with materials like Siberian sable-hair brushes that cost as much as a new car will not ease the tension.

In spite of good materials' alleged importance, they still intimidate us.

It's even worse if we are aware of how our paintings will be used later.

If you already know who might hang your picture on their wall when it's finished, or which critics will review it, you'll face a huge mental roadblock. You risk painting in anticipatory obedience to later critics. It's obvious that this won't make your process any more spontaneous or relaxed.

Tip: If you notice that you only paint under pressure, busy yourself with something else for a while. Go for a run. Afterward, you'll be able to apply yourself to painting much better.

Free yourself
from this. Think of
your picture as a
study or a draft when you begin.
Always take into account that
you paint for yourself, as an
exercise, and no one but yourself ever has to
see it. (For example, I pretend that my picture
is just the sketch and that I will paint the
"real picture" as a second attempt.)

Paint your pictures as if they are just in pro-
cess. After all, you don't accompany each
morning's run in the woods with a stop-
watch, spectators, anda live broadcast. Try
to keep it fun. This is far more important
than making it look, to viewers, like you
were having fun. And as a result, you will
realize what beautiful, carefree pic-
tures you can paint when you're not
trying really hard to paint beautiful,
carefree pictures.

17/7
EMMA

999,—€

SEEK NOT AND YOU SHALL FIND
Imagination vs. Internet

Tip: One of the best times for creative thinking is when you're still half-asleep in the morning. If you're not quite "there" yet, you're less likely to get in the way of your creativity. So, keep pencils and paper next to your bed!

Another remark on creativity: naturally, we all work with pictures. And naturally, instead of just getting to work, it is tempting to first Google some reference images.

Nonetheless, we should not forget that an Internet search cannot replace the creative process.

When you Google pictures, all you find is what already exists, what someone else saw before you and put online. Google is a search engine; it just sorts what's already out there. Therefore, you can't find anything new on a search engine, just other people's pictures. This makes matters worse, since you're walking the beaten path.

Essentially, the Internet is a library where the books borrowed most often are found right at the entrance. This causes us to borrow these books more and more. Since the structure of the search engines often favors what is sought the most, there is a high probability that we are all wandering through the Web on the same routes. As a result, we all absorb similar information and have seen the same thing.

This makes strong creative processes indispensable especially in the age of the Internet.

When you draw and conceive of something in paint, you are creating something new, something that until now was only ever inside your own head.

Make an effort to create something new instead of reproducing what's already there. Creating something unexpected and new lies within the artistic process itself. It is not goal-oriented, and it is not helpful to aim in a certain direction from the very beginning. If you already know what the end result of your picture will be, usually there is no end result at all. Quite the opposite: seek not and you shall find.

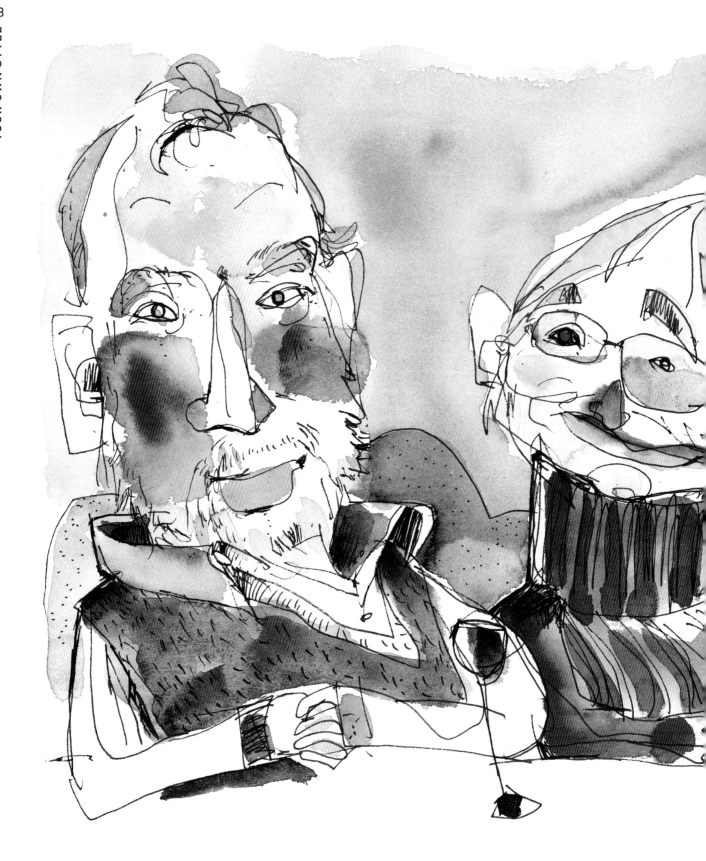

MAKE IT MATTER

What you feel while you paint a picture is far more important than is commonly thought.

Copying a photograph of a stranger, for instance, produces a completely different picture than painting your own mother. The picture of your beloved cat will look different from a study of a random turtle in a pet store. Your relationship to your subject really makes a difference.

Therefore, whether a picture is good or poor is not merely a technical question. Composition, color, and proportion can ultimately reveal how much the subject matters to you. What decides whether a picture is good or poor is mainly how you feel about it.

So, if you want your picture to be meaningful, its subject should have meaning for you. If you have a personal or emotional relationship with your subject, this meaning will creep into your picture almost magically and will also reach its viewers.

Make it matter. Then the matter will stop being just matter and will gain a soul.

How you see what you see influences your picture. You will only paint really interesting pictures if the subject actually matters to you.

MY PARENTS
ON 26/3

PRIORITIES

However, the subject's significance to us is not the only thing that determines a picture's quality. It is also exciting to be able to look back at a sketch or picture and see what was important to us while we were painting it. Every picture has various elements.

Above: A street in Romania. Especially when there is "a lot going on" in pictures, it seems difficult to set priorities.

Pictures have main focuses and supporting characters; they have insignificant things and surroundings; they have foregrounds, middle grounds, and backgrounds. And as funny as it may sound, if we treat all of this equally and with the same attention, it makes our pictures oddly meaningless. Blanket photorealism is tough on our eyes. My advice is to prioritize within your painting. Pictures become much more interesting if something is packed into them—if you can see which parts of the picture were important to the painter. This can be done with color or compositional choices, or simply a more intense, more precise execution of individual elements. You may also choose to tone down certain elements in order to emphasize others. For example, it may benefit the main subject if the background recedes. All of this focuses and guides the eyes of the viewer. So don't treat your picture equally in all places—show where your priorities lie.

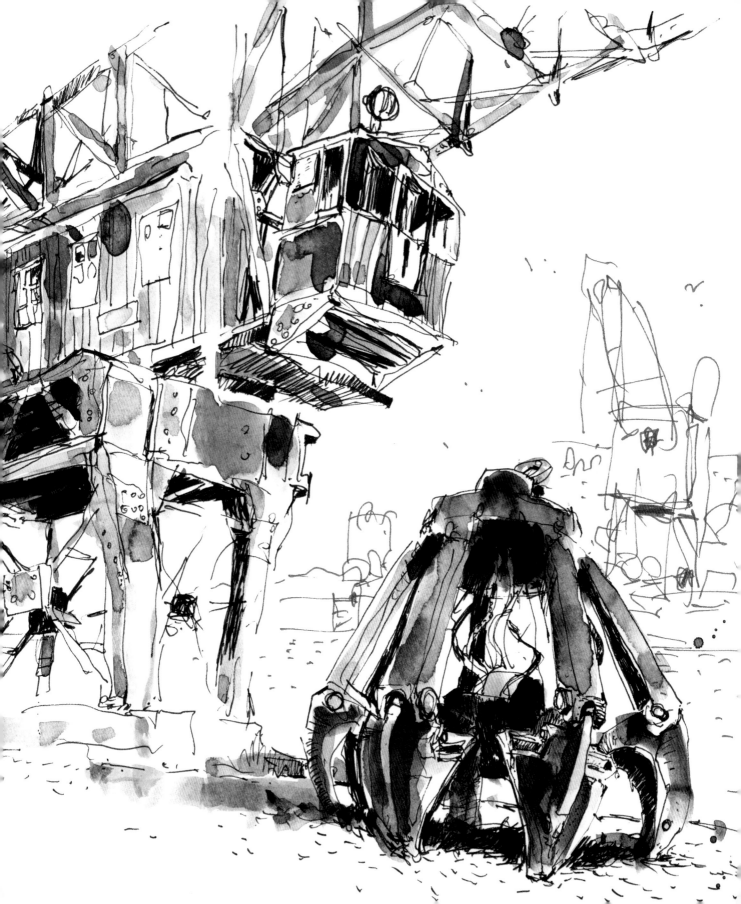

PAINTBOXES

Watercolor boxes are nifty little things: black, pristine, and shiny. They're made of sturdy black sheet metal with depressed mixing areas and little pans that hold our paints. They're ideal gifts, to be stored away and allowed to age with dignity.

But seriously.

A watercolor box enables you to work quickly—as watercolors demand—because the paints are so readily available. No screw lids, no squeezing or stirring; just easy painting.

For this reason a watercolor box is a good investment. However, there is a wide variety of boxes, all of varying quality. The most well-known (and the best) manufacturer is Winsor & Newton in England, but Daniel Smith, in Seattle, is also a great choice. Both offer excellent paints and boxes that are usually equipped with an assortment of readily mixed colors. In most cases, this assortment consists of basic colors with one warm and one cool alternative of each.

Of course, there are watercolor boxes in all sizes—from six to forty-eight pans—and at all prices. Which one you choose depends on your taste and budget. The standard twelve-pan boxes are plenty sufficient. As you know, you can theoretically mix every other color from the three primary colors. Ultimately, it's a matter of your skills and requirements—not so much of winning a prize for best materials ("My house, my yacht, my watercolor box . . .").

Remember, great materials alone do not make a good painting.

12 FULL PANS ↘

Tip: Before beginning, moisten all of the paints in your box with a few drops of clear water (even the ones you might not need— you never know). This will dilute the paints ahead of time; in case you need one while painting, your workflow will not be interrupted.

12 PAN BOX
WINSOR &
NEWTON
ENGLAND

Tip: An old artists' fallacy maintains "You don't need to clean your paintbox."

Just like your workplace, your paintbox should not be allowed to get filthy. A little cleaning now and then will make the yellow glow again like new.

Tubes versus Pans

Watercolor paint is also available in tubes. There is no difference between the two, at least in higher quality paints. Pans essentially contain the same paint as tubes, except it's dried. You can also refill the pans from your tube paints, if you wish—but then you need to allow lots of drying time.

Still, watercolor paint in pans is much faster and easier to handle. You can easily switch between the individual paints and use your paint straight from the box. Tubes provide a large amount of paint and are therefore ideal if you want to paint very large or vividly colored areas. Using pans to paint on a surface that is larger than about 11 x 16 inches will be pretty laborious. Tubes, therefore, are studio equipment. For plein air and small, rapid sketching, pans are better suited.

METAL BOX
→ 12 COLOR
IN HALF-
PANS
"SCHMINCKE"
GERMANY

UNDER SIDE

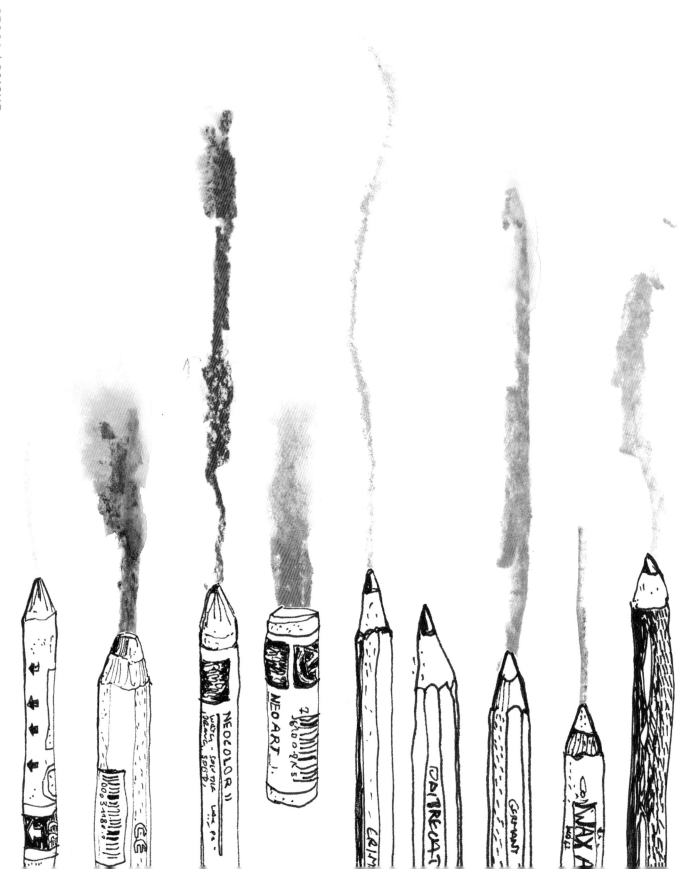

WATERCOLOR PENCILS

Tip: It's also really nice to simply draw with watercolor pencils in a moist area. If you moisten your paper, for example with a spray bottle for plants, it creates a great painting surface!

"Give your watercolor pencils to your little sister," is a widespread, but unkind opinion among artists and illustrators. As popular as these pencils may be among hobbyists, they can be a material of contention.

This is mainly because watercolor pencils are neither fish nor fowl. It's not simply a matter of choosing between pencils and paint (that choice should be easy!). When we look at them closely, they might seem inferior to both colored pencils and watercolor at first. They neither rival the luminosity of colored pencils, nor provide the coverage of watercolors, especially on large surfaces.

First we must note that the term watercolor pencil is somewhat misleading. Watercolor pencils do not contain any watercolor paint. They are not made of gum arabic and pigments but are wax pencils with a water-soluble binder. So, it is less surprising that they also behave like wax crayons. The colors do not dissolve as transparently, and they dry far more opaquely. Their covering power is quite different than that of paint. They are a compromise, but one that does offer other strengths.

I would therefore like to take up the baton on behalf of watercolor pencils, because they do offer great possibilities when used correctly.

Simply being able to combine colors and lines is a great option to have. Watercolor pencils enable you to use a little water to soften lines you've drawn and transform them into colored areas. This is valuable as an added effect and as a corrective method.

But watercolor pencils are even more interesting if we use them directly in moist areas. The line breaks up and softens, but unlike brushstrokes on wet areas, it still retains its solidity. Brushstrokes dissolve when applied wet-on-wet; watercolor pencils used for the same

application retain far more shape. This makes them a great technique for accents. It really gets interesting when we combine watercolor pencils with watercolor paint. For example, when you want something within a painted area to be a bit more solid or to intensify part of a color, nothing beats a watercolor pencil.

In places where paint might simply flow away, lines made with watercolor pencils not only stay where they are but retain their luminosity, too. Because they soften a little, though, they don't clash when combined with watercolor. On the contrary, they accommodate your picture just enough to appear organic and help you over a few hurdles when working with watercolors.

Should the opportunity arise, I suggest that you actually do borrow your little sister's watercolor pencils and use them now and then.

BUYING PAINTS

The paints you put in your paintbox are primarily a matter of taste.

There are, however, one or two things that I think you should consider when choosing your assortment of paints.

The first box you buy will probably already contain paints. However, the assortment provided is naturally a compromise between your color preferences and those of the manufacturer. To start, the paints in a beginner's set are most likely student-grade paints, which means that they are not the best quality. This is no problem for a beginner's first attempts, but you will notice the difference if, when replacing certain paints, you switch to professional-grade paints. The pigment density is higher, and the luminosity of the colors will be much better.

The mixed colors in paint sets are usually coordinated to be the most compatible with one another.

Normally, you'll receive an assortment of basic colors, with warm and cool versions of each. These may suffice for a while, but you'll soon require supplementary colors.

These sets may also contain all sorts of nonsense. As far as I'm concerned, you can banish black and white from your paint set. White comes from the white of the paper, and you can mix a much better black from blue and brown hues (such as sepia and indigo).

Of course, the colors you choose to include also depend on the size of your box.

Bigger is not always better, as you will discover when you have to lug your box around. I personally tend to prefer smaller boxes for that reason. If you have to leave some colors out in order to fit things into a smaller box, you can still mix these yourself in no time using colors that you do include.

However, it also doesn't make much sense to only carry around the primary colors. Paintboxes are made for spur-of-the-moment work. Besides spending all your time mixing, you might also want to paint occasionally.

As you paint more and more, you'll gradually change what you include in your box according to your needs. Use an assortment of basic colors and supplement it with a mix of your favorite colors based on the size of your box.

One additional aspect that is really important to me is buying colors that are difficult to mix. There are colors that you can easily mix from existing hues, but there are others that are almost impossible to mix yourself. Olive green, for example, can be mixed in no time from brown and grass green. On the other hand, a strong turquoise or magenta cannot be reproduced, or only with great difficulty. I would therefore advise you—in addition to the primary colors—to purchase colors such as these, which are not so easy to mix from existing hues.

Tip: In my opinion, you can toss black and white from your box and you'll never miss them.

The symbols on your paints mean:

Square: transparency
Empty square: transparent
Half-filled square:
semi-transparent
Filled-in square: opaque

Star: lightfastness
How resistant to
daylight is your paint?
(Up to five stars)

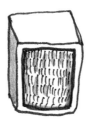

ORIGINAL
ASSORTMENT "COMPACTBOX"

224

349

353

494

492

Triangle:
reusability of the hue
Empty triangle: fully reusable
Half-filled triangle: somewhat
reusable
Full triangle: difficult to reuse

649

663

780

The number in the circle:
price category (ascending)

655

534

From: Schmincke
assortment

MY TRAVEL BOX
HORADAM

HALF
PAN

349 **655** **654** **663**

FULL
PAN

 519 **480** **488** **485**

MIXING PAINTS

You already know that you can mix any color from the three primary colors. Watercolor paint in particular is excellently suited for this, because with transparent colors you can theoretically produce an endless number of shades. Nonetheless there are a few things to note when mixing:

As mentioned before, not every color can be reproduced successfully. Colors like gold and silver are difficult because their effect is not primarily derived from color but from metallic particles.

The same applies for luminescent and neon paints, which usually contain chemical reflectors as additives. Since these additives are, of course, not available for mixing with the primary colors, it is difficult to imitate these colors. (Incidentally, these colors also don't mix well with others.)

However, mixing colors is an extremely worthwhile and important practice, since we don't always have (or even want to have) every color at hand. But pay attention to the following:

As a basic rule, it is best not to mix more than two colors together at a time. Of course, in later stages (where you might actually combine color mixtures) anything goes, but if you stir together more than two colors at a time, things get confusing and difficult to control.

It is also important to add the darker hue to the lighter hue when mixing, and not vice versa. This is because a darker hue can quickly swallow up a lighter hue without changing much, while you only need a small amount of the darker color to alter a lighter color. Because the lighter color is more sensitive to change, use it as the base color when mixing.

Try practicing a few mixtures to get a feel for the process. Start with a lighter color, and carefully add more and more of a dark color until you achieve the hue you want.

You'll see that the old technique of mixing—somewhat forgotten due to the overabundance of hues in our sets—is a very decisive step in developing a good feeling for color.

Tip: Make samples of your mixed colors on scrap paper. This will spare you from encountering unpleasant surprises in your finished picture.

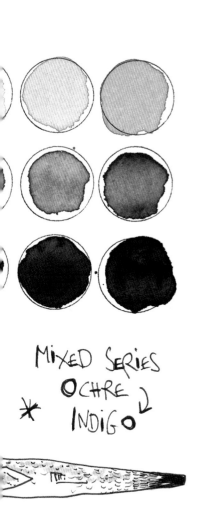

MiXED SERiES
OCHRE
* INDIGO

Tip: You can mix colors in the palette of your paintbox, but if you want to achieve very pure hues without any impurities, it is better to use small, clean pans or glass plates. Although the extra palettes in stores look really nice, a large dish works just as well.

Brushwork

How you work with the brush influences how you apply your paint. Pressing harder on the brush head results in a different stroke than if you just graze the paper with the tip.

In addition, the anatomy of our arms makes it easier to gesture outward away from the center of the body than to move in toward the body. It is therefore best to paint this way. Don't clench your muscles. Use the brush as if it were a natural extension of your hand.

Also, don't hesitate to turn the paper around. It is far better to paint with the subject upside down than to turn yourself upside down with frustration.

By the way, you can reuse any paints you have mixed after they dry by rewetting them—even months later.

MiXED SERiES OCHER → HELiO TuRQUOiSE

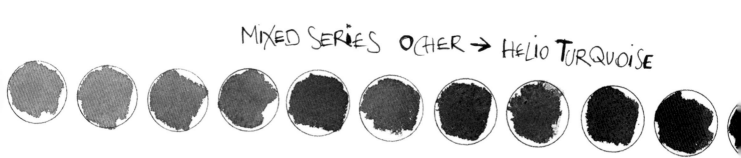

IMPOSSIBLE HUES
Bright Colors

Let's not kid ourselves: Watercolor paint is weak if we're after bright colors. It can't match the luminous colors of a computer screen—and also lags behind its brother, oil paint, its sister, acrylic paint, and its cousin, ink. If we want bright, saturated, flashy colors in our sketches, we've got the wrong medium. Watercolor paints are known for creating delicate, pastel hues. Areas painted with watercolor simply aren't as pigmented as those painted with nontransparent mediums. If need be, oil paint can be applied like a paste in layers that are half an inch thick. By contrast, watercolor paint is a delicate kind of paint that creates a delicate effect.

Because most watercolor paints contain natural pigments, you will not discover many artificial or gaudy colors in your set.

Furthermore, while painting, colors overlap and influence one another because watercolor is transparent. When you apply a layer of paint over another, it visually blends with the color beneath it, creating a new hue. For example, if you apply a layer of red on top of a layer of green, you'll get brown. This isn't the case for thick, opaque paints such as acrylics, and it may seem like a disadvantage of watercolor.

Yet, on closer look, a medium that readily blends like this has its benefits. If you look around at your environment, you will notice that there are not many intensely bright colors in our surroundings. Just take a look out the window. If you don't live in Times Square or aren't standing in the middle of a poppy field in midsummer you probably recognize that the dominant colors in our environments are not garish hues.

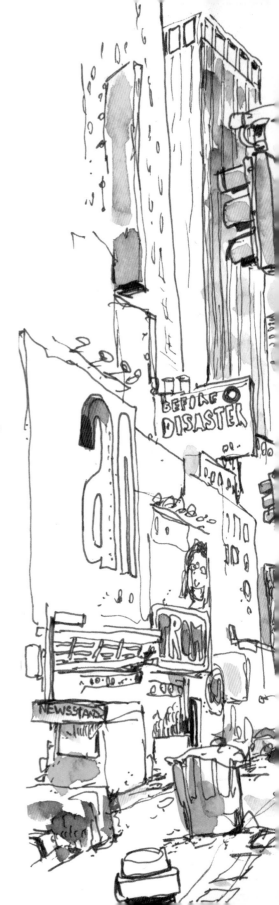

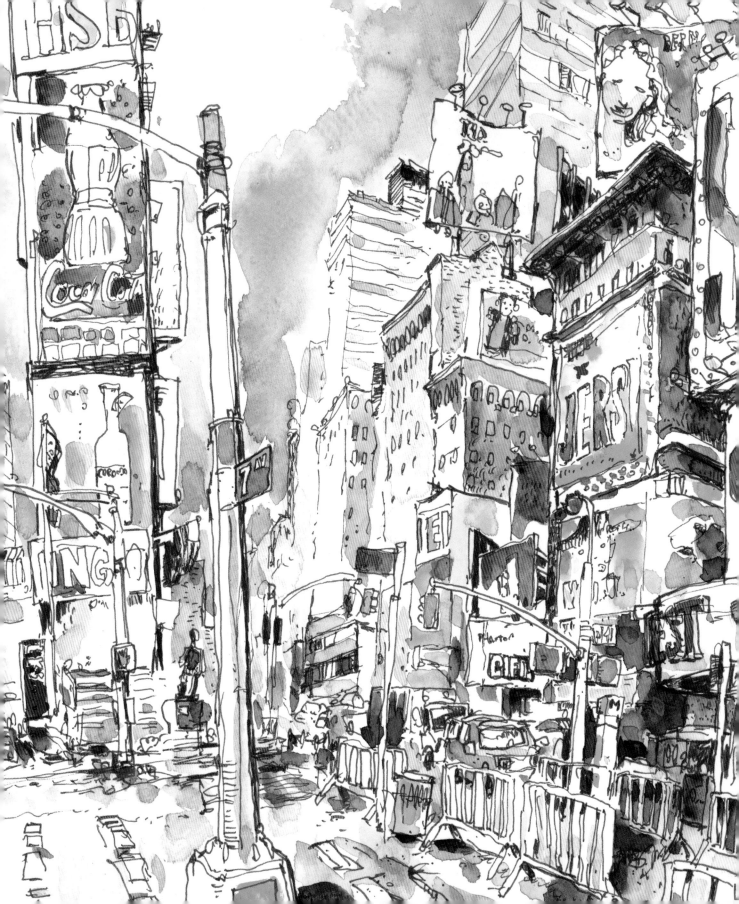

PIMPING WATERCOLORS
Making Colors Pop

Generally, when light hits a surface, it is reflected, dissipates in the air, and blends with other surrounding colors. The colors jibe with one another because they belong to the same environment and thereby work together to create a general mood or atmosphere.

Most of the bright colors that we encounter in reality do not come from reflected light but are emitted by artificial light sources. We find them in lamps, monitors, LEDs, neon lights, etc. This emphasizes the advantage of watercolor paint: due to translucency, interweaving, and overlapping, the color in a watercolor painting actually mimics the reflection of "real" light. That is why we can use watercolors to portray light so well. By intermingling different colors, we simulate the way that light naturally behaves. This is one of the much-trumpeted "natural qualities" of the watercolor palette.

However, it gets difficult when you try to depict very intensely colored subjects, as you might if you tire of autumn landscapes. Painting a street full of neon lights with watercolor paints will at first seem like fitting a square peg into a round hole. There are a few tricks, though, and the next chapter will discuss some techniques you can use to spice up your colors.

The first thing you can do to make your paints glow is to use them efficiently. I don't mean that you should work faster but that you should not keep painting layer over layer. When you re-wet watercolors, they lose their luminosity. Watercolors are at their most vibrant when they are left to dry without lots of manipulation.

Another option for making your watercolors pop is to mix your paint with other more luminous colors. There are a number of different paints, inks, and colored pencils available in bright hues. Many of these mediums move into the background of the finished picture, so they will not dominate your watercolor but all in all will greatly emphasize the colors in your paintings.

ARTIFICIAL LIGHT
≙ ARTIFICIAL COLORS.

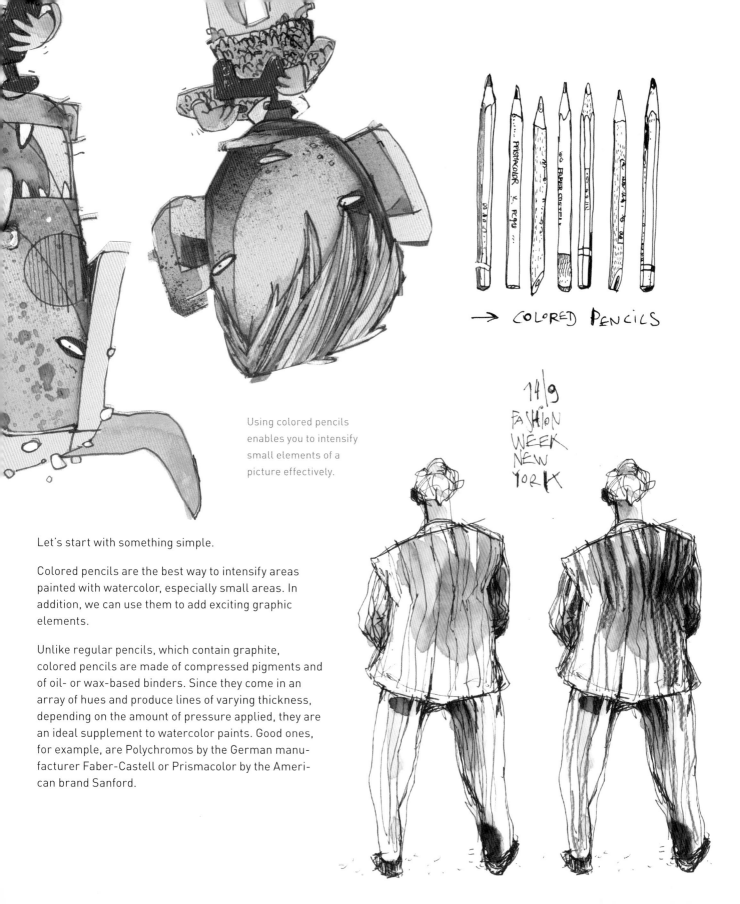

→ COLORED PENCILS

14/9
FASHION
WEEK
NEW
YORK

Using colored pencils enables you to intensify small elements of a picture effectively.

Let's start with something simple.

Colored pencils are the best way to intensify areas painted with watercolor, especially small areas. In addition, we can use them to add exciting graphic elements.

Unlike regular pencils, which contain graphite, colored pencils are made of compressed pigments and of oil- or wax-based binders. Since they come in an array of hues and produce lines of varying thickness, depending on the amount of pressure applied, they are an ideal supplement to watercolor paints. Good ones, for example, are Polychromos by the German manufacturer Faber-Castell or Prismacolor by the American brand Sanford.

LIQUID WATERCOLORS
Bright Now, Pale Later

Another good way to give your paints a boost is to mix them with other watercolors. Liquid watercolors are particularly suited for this. They are not purchased in pans, but in liquid form. They are usually artificial pigments used as is or mixed with water. The Dutch company Royal Talens, for example, offers a whole palette of colors under the trade name Ecoline. The distinct advantage of these colors is their luminosity.

A cross made of traditional watercolor paint (horizontal brushstroke) and liquid Ecoline paint (vertical brush-stroke). The difference in the colors' intensities is obvious.

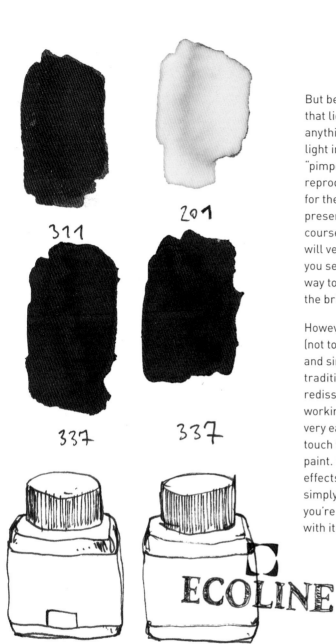

311

201

337

337

ECOLINE

But beware, there is a catch to the artificial pigments that liquid watercolor paints contain; they are often anything but lightfast. They react sensitively to sunlight in particular. Therefore, pictures that have been "pimped out" with Ecoline are more practical for reproduction (printing multiple copies) than they are for the wall. If you are painting a sketch to use for a presentation or for printing, this is not a problem, of course. But if you plan to hang it on a wall, the light will very soon rob it of its bright colors. Therefore, if you seek vibrant, colorful paints, this may not be the way to go. Liquid watercolor paint is a bit like a flame: the brighter it shines, the sooner it goes out.

However, we should note that liquid watercolor paints (not to mention inks, retouching dyes, airbrush paints, and similar products) are not as easy to work with as traditional paint from pans. Ecoline, for instance, redissolves very easily, which is a disadvantage when working with glazed layers. This also causes it to bleed very easily into neighboring areas if you accidentally touch them with your brush when applying the paint. Nevertheless, you can still achieve very nice effects in a picture, especially with Ecoline. You simply have to make sure that you use it last if you're glazing and that you do not repaint areas with it.

WATERCOLORS.

ECOLINECOLORS.

INTO THE WILD
Brushes

Humans have been using brushes ever since they started to paint, and humans have been painting for a very long time.

The ancient Egyptians used roughed-up rushes and the ear hair of cattle to color their hieroglyphs and tomb paintings, and the Romans used feathers and goat hairs to paint the frescoes on the walls of their houses.

The first written description of something close to professional brushes comes from *Il libro dell'arte* (*The Craftsman's Handbook*), in which the fifteenth-century Italian painter Cennino Cennini explained their precise manufacture. In fact, until the end of the nineteenth century, painters not only made their own paints, but also their own brushes.

ROUND BRUSH (SQUIRREL HAIR)

Even Stone Age painters used primitive brushes to paint bison, deer, and horses with pigments made from red hematite and ocher on the walls of their caves. Brushes fashioned from hollow bones, feathers, and hairs have been found, for example, in the caves of Altamira in Spain.

Brushes depend on the spaces between the densely bundled hairs to both absorb and dispense liquids. Although this principle has been known for a long time, it took awhile for brushes to achieve the quality we need for painting with watercolor.

Tip: There's an unconventional trick for getting your brush pointy again after painting and washing it: put your brush in your mouth and sharpen it by twirling it with your tongue. Just make sure that you only do this with brushes that have been completely cleaned of all paint. Don't forget that even watercolor paint can contain toxic pigments!

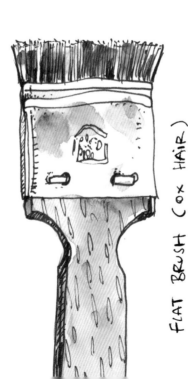

FLAT BRUSH (OX HAIR)

PORTABLE BRUSH (RED SABLE)

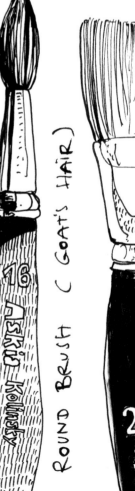

16 Askü Kolinsky

ROUND BRUSH (GOAT'S HAIR)

20 da vi

Today there are countless types of brushes around, and art supply stores carry a huge amount of merchandise. So, the question is obvious: Which brushes do we really need? Is a precious Kolinsky sable brush necessary or will a synthetic brush for the price of a cup of coffee do?

FLAT BRUSH (RED SABLE HAIR)

FLAT BRUSH (OX HAIR)

ROUNDED FLAT (OX HAIR)

FAN BRUSH (GOAT'S HAIR)

6

ROUND BRUSH (SYNTHETIC)

FLAT BRUSH (PIGS BRISTLES)

Tip: A good brush not only releases paint but also absorbs it again. When you pat your brush dry on a tissue, you can use it to "wick up" pigment again.

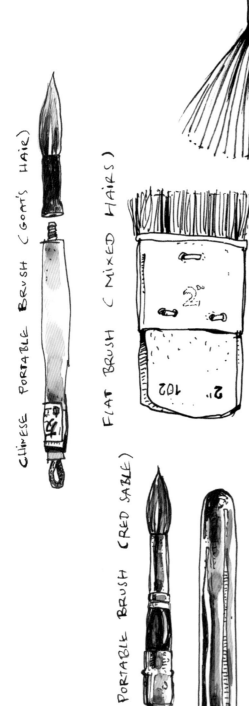

CHINESE PORTABLE BRUSH (GOAT'S HAIR)

FLAT BRUSH (MIXED HAIRS)

BRISTLE BRUSH (PIG'S BRISTLES)

PORTABLE BRUSH (RED SABLE)

EVEN MORE BRUSHES

Maybe we should begin systematically.

All brushes can be roughly categorized into two basic shapes: rounds and flats. The main difference is the shape of the ferrule, which determines whether the tuft has a round or flat form. The round brush is very useful simply because it has a pointed tip. Flats may be very suitable for large areas, and they can be replaced by thick rounds but not vice versa. Let's talk about the rounds first.

Rounds are available in all sorts of materials and sizes. When you hold the brush in your hand, the first thing you'll notice is the number on the handle, which delineates its size. There are a number of increments, beginning with 0 and usually ending at 24. The differences are so fine that these increments aren't very important. You will learn, however, that most painters do have a precise idea of what sizes they like to use when painting.

If you want my advice, you only need two brushes when you're just starting out—a big one and a small one.

What precisely is meant by big and small (and what material the brush is made of) should be decided by your budget. Even investing in the largest, most expensive Kolinsky brush (made from the fur of the Siberian weasel) alone will not give you the skill to solve every painterly problem. To give you some numbers, I would recommend two brushes, sizes 6 and 10, to start with.

A good watercolor brush should be pliable and soft. It should pick up the paint well and have a very pointy tip. The handle should not be too long and the ferrule should be precisely shaped without any single hairs splitting out. A natural-hair brush is the best, but since these are expensive, synthetic will also do for a start (especially for larger and thus more expensive brushes). You can also find brushes that mix synthetic with natural hairs. Other alternatives are squirrel or ox hair, which are relatively moderately priced. When you are just

Tip: Portable brushes with a cap that also serves as the handle are great for traveling!

FLAT BRUSH (RED SABLE)

12 NATUR

BRISTLE BRUSH

CHINESE ROUND BRUSH

FLAT BRUSH

ROUND BRUSH (RED SABLE)

12

ROUND BRUSH I (SYNTHETIC)

ROUND BRUSH (GOAT'S HAIR)

.6

starting out, you don't need a vast assortment of brushes. Later, you can gradually supplement your collection.

This also applies to investing in flats for even glazing and to petit-gris brushes for applying large shapes or washes. These brushes are useful, but since their specific characteristics can also be replaced by large rounds, they should not be a top priority to purchase (this applies all the more to specialized types, like fan brushes or riggers).

The best brushes are Kolinsky sables. These brushes are very expensive. However, they also last a long time if cared for. If you always wash your brushes with soap after use, you will be able to enjoy them for a long time.

Do not, however, let yourself be fooled into thinking you can't paint with less expensive brushes. Sometimes people buy sable-hair brushes, saying to themselves "Well, if it's sable . . ." only to find that the brush still doesn't fix all the problems they thought it would. A good synthetic brush may be better, and will definitely be more affordable. But, it's a little like a good wine: you need a great deal of experience to even taste the difference. I therefore advise you to start out with synthetic brushes.

At any rate, the important thing is what you do with your brushes. Brushes are really just an extension of your hand, and it's your hand that is ultimately responsible for your painting!

PAPER

Paper was invented by the Egyptians. The word comes from Egyptian papyrus, a fibrous water plant from the Nile delta that was dried and that the pharaohs used to write on. However, the Mayans developed a similar paper, amate, which was made of pressed plant fibers from a wild fig that were dried in layers to make larger sheets. Both essentially look a little like woven bark.

But the first paper that really looked like today's paper was developed by the Chinese almost two thousand years ago.

Paper is made from cellulose (found in fibers and wood), which is cleaned, boiled, mixed with glue, and dried in layers. In records that date as far back as the first century, the Chinese minister Cai Lun describes the manufacturing process during the Han Dynasty in detail (there were already tissues and toilet paper in fifth-century China). The cellulose pulp made of silk residues and bast, which is a fiber collected from the inner stem of plants, was cooked and dried on screens.

In the late Middle Ages, the Chinese method of papermaking reached Europe via the Silk Route and the Arabic world. Until then, parchment or dried animal hides smoothed with pumice stone had been used for writing in the West.

The advantages of paper were obvious; it was cheaper than parchment and was available in large amounts and consistent quality.

The Europeans used this new knowledge and soon developed the proper technology for paper production. New types of screens and water-powered paper mills soon facilitated mass production.

Even if it took another five hundred years to develop today's paper machines, which can churn out over 6,500 feet of paper per minute, watercolor paper is still very similar to the paper made in the beginning in China.

Watercolor paper contains practically no wood and is made primarily of linen or cotton. This makes it more tear-resistant and enables it to absorb paint better. It is usually handmade (recognizable by the irregular, or deckle, edges of the sheets) and sold as individual sheets or in glued blocks.

Watercolor paper also comes in different finishes: coarse, medium, or smooth. Smooth paper is dried with hot cylinder presses (hence its name hot-pressed paper) and is primarily suitable for illustrations. Rougher finishes, or cold-pressed papers, have the advantage that the paint adheres better, and they slow the paint's drying time. However, it is harder to erase on these coarser papers.

Choosing a texture merely comes down to preference, since paints behave differently on each kind. Many papers also have a coarse and a smooth side, both of which you can use for painting.

However, it is not a matter of preference, but an important criterion, that your watercolor papers are acid-free. Acids, used to bleach mass-produced paper, destroy the paper over time and also considerably influence the paint's appearance on the paper.

You'll notice that there are many different weights of paper that you can buy. The heavier the paper, the more water and reworking it can tolerate. The most commonly used weight is 140 pounds.

Regular office paper, for example, weighs 80 grams per square meter (gsm). Watercolor paper is much thicker; it usually weighs 200 to 300 gsm. Of course, you can purchase much thicker paper, but at a higher price.

Tips: Sheets or blocks? The answer is not either/or, but both. Both have their advantages. For a start, blocks are the simplest. In addition, the pre-glued blocks, glued on all four sides, are good for traveling and spontaneous work. If, however, you want to work with larger formats and simply prefer to use more inexpensive paper, I would advise you to use loose sheets. If the cockling, or buckling, of the wet paper bothers you, you can easily stretch the paper with mounting tape, as described on page 113.

ARCHES SMOOTH
(CALENDARED) 185g

ARCHES COARSE
300g.

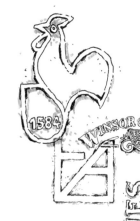

Watermarks are thinner layers in the paper that are reserved or embossed during the manufacturing process to guarantee authenticity. Here are some watermarks of famous manufacturers.

These kinds of investments don't exactly help banish any fear of that empty sheet of paper. From my point of view, the affordable solutions are good enough. I often use off-the-shelf matte-coated 185-gram paper (Hahnemühle or Arches) that I stretch myself.

I'll show you how to do this on page 113.

Whether it was the Chinese, Egyptians, or Mayans who invented paper is inconsequential. We really have nature to thank for paper. Wasps and hornets have always built their nests of masticated plant fibers, a pulp of cellulose and starch, which dries in the sun to make delicate paper structures.

Above: Ultramarine blue on "upscale" paper (Arches 650 gsm) and to the right of it on "regular" paper (Hahnemühle 200 gsm).

REAL
PAPYRUS

INGRES PAPER
100g.

ENGLISH HAND-MADE
WATERCOLOR PAPER
300g.

SCHOELLERHAMMER
COARSE GRAIN
300g.

FABRIANO
COARSE 300g.

HAHNEMÜHLE
TORCHON 300g.

THE PERMANENT WAVE
Stretching Paper

It's exasperating; you get the paper wet (paint on it with too much water), and it starts to warp (a process known as "cockling"). In next to no time the smooth, white surface transforms into a marshy landscape. If that weren't bad enough, the material that was easy to handle a moment ago becomes uncooperative. The paint gathers in puddles in the newly formed valleys and leaves ugly blotches when it dries. The more you paint over it, the worse it gets, because no matter what you do, you can't eliminate these valleys with a brush.

People are constantly coming up with new ideas to solve this problem. Cockling is more common when working with thin papers. You can try a thicker paper, but this still won't completely prevent the page from warping. Pre-glued paper watercolor blocks aren't a great alternative, either. For the price of these watercolor blocks, they aren't a great solution to warping. Although the paper does warp less, the blocks can be cumbersome. It's difficult to place a watercolor block on a drafting table, for example, to trace a preparatory drawing. As good as blocks may be for when you're on the go, they aren't always suitable for more developed works.

In order to understand how to prevent cockling, one needs to know exactly what causes it first: Paper consists of fiber. It is usually made from cellulose, wood fiber, recycled paper, or cloth, which is ground to a pulp in paper mills and then dried in layers. These fibers form the base of the paper, held together by glue and pressed in layers.

If we moisten the paper again, the fibers begin to swell, and each fiber pushes the fiber next to it a little to the side. The fiber next to that one—also busy spreading itself out—nudges its neighboring fiber. Since all of the fibers are doing this at once, waves, valleys, and hills are created. Furthermore, water gathers in the valleys, resulting in the fibers that are located there swelling even more, which in turn enlarges the valleys. A chain reaction begins, and the more unevenly the water is distributed, the greater the effect will be.

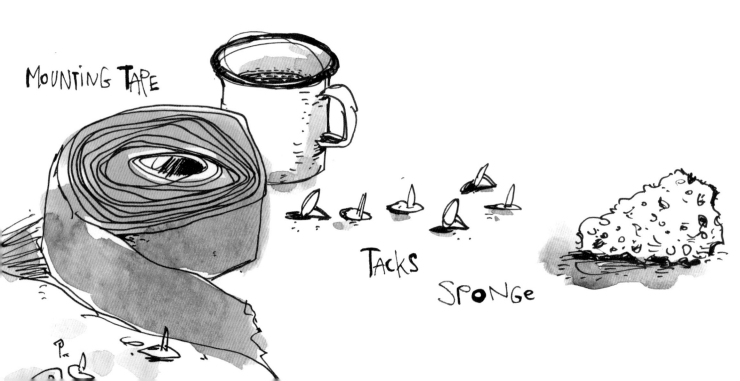

MOUNTING TAPE

TACKS

SPONGE

Tip: I always stretch a few sheets of paper in advance on boards and let them dry overnight. Then, I have my paper ready when it's needed.

It sounds disastrous, but there really is a solution: stretching the paper. Using this method you can even use lighter (and therefore less expensive) papers for watercolor painting. This is how it works: Since every fiber expands when it is moistened and contracts again while drying, we ensure that all of the fibers in the paper are evenly wetted. To do so, we first immerse it in cold water for a few minutes. A large, flat plastic basin from a photography store is best suited for this, but a bathtub will do, too. This makes all of the fibers absorb water and expand evenly.

Once the paper has soaked for about a minute, lay it on a wooden board and attach it with gummed tape or artist's tape at its edges.

Now, when the paper dries and contracts again, the fibers will be held taut by the tape, just like the skin on a drum. When it is moistened again during painting, it no longer has the capacity to expand and produce cockles. Professionals always stretch their papers. All that you need are a board made of plywood (such as birch plywood from a hardware store), a cloth or paper towels, gummed tape or artist's tape, a few tacks, and single sheets of paper in any weight.

Here's how to stretch paper:

1. Immerse your paper completely in cold water for approximately one minute.

2. Now, remove it quickly and let it drip briefly (do not take too much time; it's all a matter of speed).

3. Lay the paper on a wooden board and stretch it smooth with both hands. Dab at it briefly with a cloth or a paper towel.

4. Affix the paper to the board along all four sides with moistened gummed tape and attach the corners with the tacks.

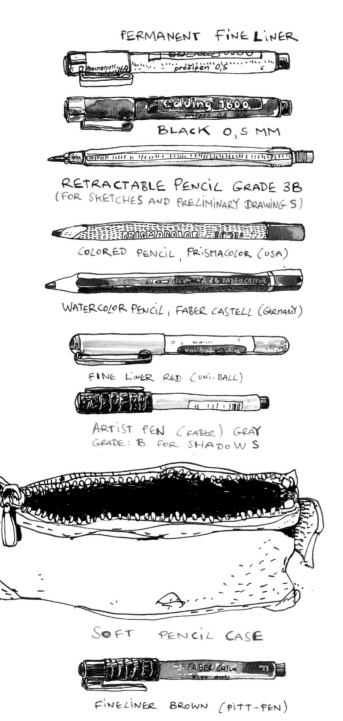

PERMANENT FINE LINER

prötipen 0,5

edding 1800
prötipen 0,5

BLACK 0,5 MM

RETRACTABLE PENCIL GRADE 3B
(FOR SKETCHES AND PRELIMINARY DRAWINGS)

PRISMACOLOR

COLORED PENCIL, PRISMACOLOR (USA)

FABER CASTELL

WATERCOLOR PENCIL, FABER CASTELL (GERMANY)

Uni-ball

FINE LINER RED (UNI-BALL)

ARTIST PEN (FABER) GRAY
GRADE: B FOR SHADOWS

SOFT PENCIL CASE

FABER CASTELL

FINELINER BROWN (PITT-PEN)

SHARPENER FOR
RETRACTABLE PENCIL

THE CONTENTS OF MY BAG

Art supply stores can be quite awe-inspiring. Materials tower on yards and yards of shelves, and suggest that you need a huge amount of basic equipment. But what is really necessary? What painting utensils are we spending money on needlessly? I brought some things along to help you decide what you need.

Since watercolor is the classic plein air technique, in my opinion, all we need for painting is what we carry in our bags while traveling. When we travel, we take necessities—and nothing more. After all, we don't want the weight of our bag to dictate how much time we can spend seeking out a subject. Ideally, your bag contains only what's absolutely necessary for painting.

Apply this idea to your studio, and you'll see that you usually do not need much more to paint. Perhaps at home you'll add a pencil or brush, maybe a hairdryer, or things like adhesive tape or frisket, and maybe at home you'll have a few more paints or papers at hand. Although it is, of course, a matter of taste, basically the contents of our bags show what is really needed and most useful in practice.

So, let's take a look inside my shoulder bag.

TISSUES
* (AT HOME I U⌈
A SPONGE OF
A CLOTH)

Tip: A folding chair may be quite comfortable to sit in, but you still have to lug it around with you. A small mat is easier to carry.

 INDIA INK
(SEPIA
OR
BLACK)

INK ↗

 SHARPENER
(FOR COLORED
AND
REGULAR PENCILS)

WATER CUP

Tip: Not transferable to the studio, but also useful in transit: sunscreen, a small foldable umbrella, and bug spray.

RUBBER
ERASER
(SMALL)

CLIP FOR
SKETCHBOOK
→ PRACTICAL
IN WIND +
WEATHER

PORTABLE BRUSH
(RED SABLE)
WITH REMOVABLE
CAP | HANDLE (ASKIA)

SYNTHETIC BRUSH

PORTABLE
WATERCOLOR BOX
(14 HALF PANS)

POCKET
KNIFE
FOR
SHARPENING,
CUTTING
PAPER
AND CARVING
REED
PENS

GOLD GREY IV

Karisma Black - 935

ENGLAND DERWENT · COLOURSOFT 520

MISCELLANEOUS COLORED
& WATERCOLOR PENCILS

WATER CUP

TOOTHBRUSH
(FOR PAINT SPLATTERS + TEXTURES)

WATER BRUSH (WITH
WATER RESERVOIR)

← PAPER (BLOCK OR SKETCHBOOK)

BAD WEATHER
Painting Outdoors

Sometimes people say, "There's no such thing as bad weather, just bad clothing," when they actually mean you should stop whining and that it's your own fault for not wearing a snowsuit for the Sunday stroll in the park.

Sketch from skiing vacation painted using gentian schnapps.

Nonsense! If you look out the window on an average November day, you will probably feel as though the weather is, indeed, bad—sometimes even very bad. Since watercolor is excellently suited for outdoor painting, it is expedient to say a few words about painting in bad weather here.

The saying above rightly points out that you can protect yourself with suitable apparel. It goes without saying that raingear and warm clothing are helpful. In the winter you need gloves (with the fingertips cut off) and a hat to make working outdoors bearable. It is just as important, of course, to protect your materials and picture. Only your technique should involve wetness. Nothing is more useless than paper that has been rained on (although rain does create a lovely atmosphere as a subject). It is therefore essential to always take an umbrella along.

But things really get problematic when it is truly cold.

Snowy landscapes are fantastic subjects, but water freezes at 32 degrees Fahrenheit. From one moment to the next, the thin layers of the glaze in particular freeze into sheets of ice that glob up the paper. In addition, your paint clumps right on the brush, rendering it useless.

In short: There is such a thing as bad weather, especially when it comes to watercolors, because you cannot work outdoors when the temperature drops below freezing.

The solution to this sounds a bit off-the-wall but is quite simple: replace the water with alcohol.

Alcohol has a lower freezing temperature than water. Clear, transparent hard liquors (such as vodka, fruit schnapps, or grain alcohol) only begin to freeze when the temperature reaches well below zero and work perfectly for painting. You would use these basically the same way you use water, but be sure to only use clear alcohol (not Jägermeister or something similar, of course) and wash out your brushes thoroughly with water when you get home. As long as you don't take too many sips of your "water," this method can assure you a successful winter painting. For there is one thing we can say about bad weather with certainty: it may not feel very pleasant, but it sure looks great.

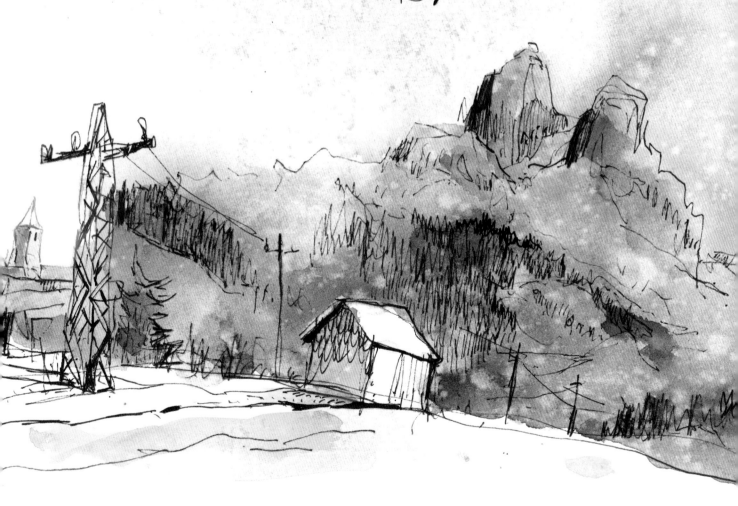

SUNSET 30/1
ZÖBLEN │TIROL ←
TANNHEIMER VALLEY
-10°C (PAINTED WITH SCHNAPPS)

THE OTHER VIEWPOINT
Changing Perspective

"Do you see the moon over Soho?"
"I see it, darling."
—Macheath and Polly in Threepenny Opera

We never all see the same thing. We always perceive
the world from our own perspective. Two people walk-
ing down the same street see entirely different things.
When we talk about a mutual experience, we usually
stress very different aspects. Macheath and Polly are
not seeing the same moon. Each of them is seeing a
different one.

At first, this sounds alienating, but it is also somewhat
reassuring. Since the world is colorful and diverse,
our personal perspective is as justified as that of
those around us. It is therefore complete nonsense to
ask ourselves whether our pictures represent a sub-
ject realistically or not. There is no objective viewpoint
in painting; pictures can do no more than portray
one's own way of seeing.

So, don't drive yourself crazy. It's your picture, and all
that is important is developing your own vision. It only
needs to please you; pleasing everyone isn't possible,
anyway.

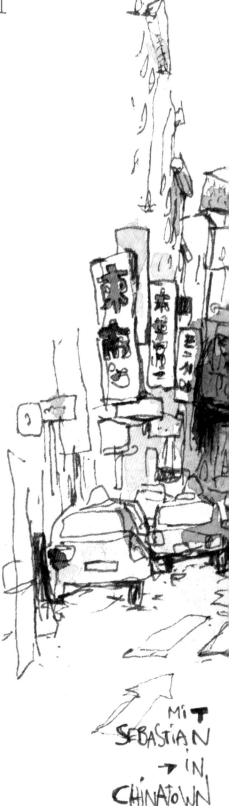

MIT SEBASTIAN → IN CHINATOWN NEW YORK

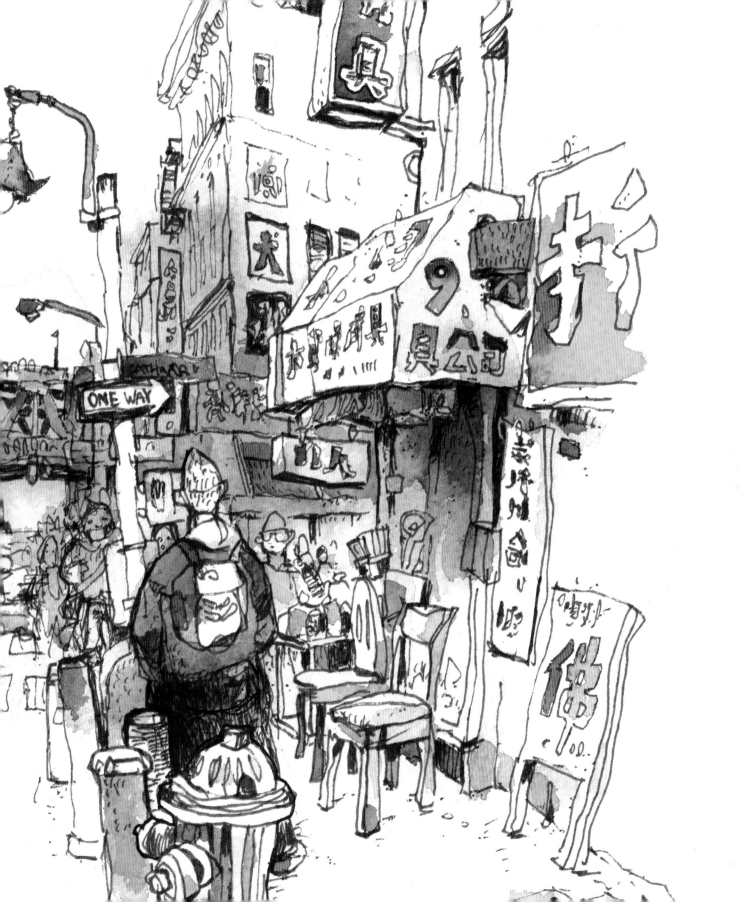

PAINTING WATER

The interesting thing about water is that it unites both shadows and light.

Typically, surfaces are dominated either by light or shadow. The one may dissolve into the other, but in the case of water, we have both phenomena at the same time. Light and shadows reflect simultaneously right next to each other on its surface. This makes water an exceedingly attractive, but difficult, subject. Water is a restive mirror that our eyes are sometimes able to pierce. It gushes, flows, trickles, drips, sloshes, runs, and breaks on shores.

Therefore, watercolor is perfect for portraying water. Its spontaneity in particular can easily render the fluidity and constant motion of water.

The most noticeable thing about water is its reflective nature. It is therefore relatively simple to portray water by not painting the water itself, but the elements we see in it. Water is especially convincing if these reflections are not direct copies of the objects themselves.

For example, paint a stick straight until it meets the water, and then break its reflection into curves that follow the motion of the water. The further its reflection glides across the water, the more it is contorted by the motion of the waves. If you depict reflections in water well, you're already halfway to drawing water itself well.

Another noticeable thing is that water essentially has no color. Think of a glass of water. Its only color comes from impurities.

You might assert that water is blue, but that is not always true. Fresh water in particular—rivers and lakes, ponds, etc.—is often dominated by brown and green tones. The blue that we see, in the ocean for example, is usually just the sky being reflected on the water's surface.

Therefore, we can almost always choose a similar color for the sky as for the water. If you continue painting your sky farther down on the page, and paint in little reflections of trees, clouds, or whatever you like, you'll have created the water. If you reserve spots of the white paper as small waves or reflections, the effect is quite convincing.

The easiest way to paint water is to paint what is reflected in it.

Make sure that the bright reflections on the water's surface correspond to the brightest parts of the sky.

Imagine a cube made of mirrors in the sun. One surface is turned toward the sun and one is turned away. The side that faces the sun is very light, and the side that faces away is dark. This is a little bit how the waves in water appear. It's easy to paint this if you start with a medium hue. As always with watercolors, do not paint the lightest areas at all; simply let the white of the paper take care of a wave's crest.

The second step is to paint the valleys. Essentially, every mountain has a valley, and that's exactly how you paint the small waves in water. The white combs are followed by darker valleys.

If you include the reflections of riverbank slopes, trees, buildings, or similar, you'll get a pretty decent depiction of water.

Look at it this way: The nice thing about watercolor paint is that its structure is similar to water's. The glazed layers make it as transparent as the actual element. Skillfully positioning washed areas and glazed depths allows you to render water in next to no time. If all else fails, you can always include something swimming in the water. Add a duck or a boat and your water will be recognizable no matter what.

5 of JULY 2010
HONFLEUR
NORMANDIE
FRANCE

Tip: Sky and water often are almost the same color, because the former is reflected in the latter.

AIR, FOG, SMOKE

As strange as it may sound, one of the most marvelous painting subjects is invisible.

Even though we usually cannot see it in real life, air simply looks great in a picture. Everything that makes landscapes and spaces magical, the fog that lays itself over the land, a veil of clouds, a wisp of smoke, a haze, everything we describe as atmosphere, is air. Air is matter. When it is filled with clouds, smoke, or mist, it is just highly visible air.

In the sixteenth century, it is said, the English seafarer Sir Walter Raleigh wagered with Queen Elizabeth I that he could weigh the smoke of a cigar. Of course, the bets were laid high. Weigh the smoke of a cigar? Impossible! Raleigh smiled, twirled the cigar between his fingers and laid it on the scale. He wrote down the weight in his notebook and lit the cigar. When he finished smoking it, he weighed the ashes and calculated the difference. The difference, he declared, was the weight of the smoke. He was not incorrect.

If we were able to put air alone on a scale, we would ascertain that 61,024 cubic inches of air weighs about 2.8 pounds. In pictures, the depiction of air—layers of air and haze—is invaluable, since what we call atmosphere creates atmosphere. Air transports moods. Fog, smoke, haze, or blurs have narrative force. So, how do we depict air?

The term *atmospheric painting* didn't come out of the blue; air has a huge impact on our pictures. Especially when joined by haze, fog, or dust, the effect is very noticeable: The thicker the layers of air, the paler the subject behind it. The subject loses contours and intensity, and the original luminosity of the colors disappears.

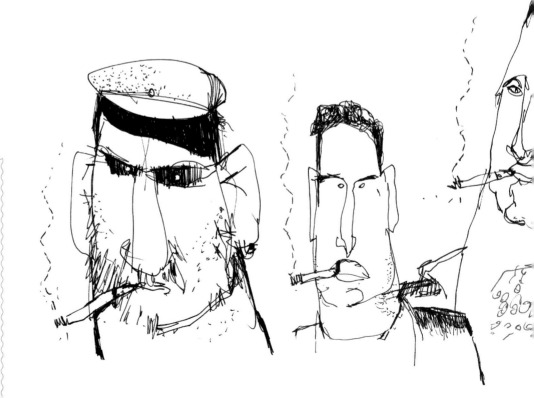

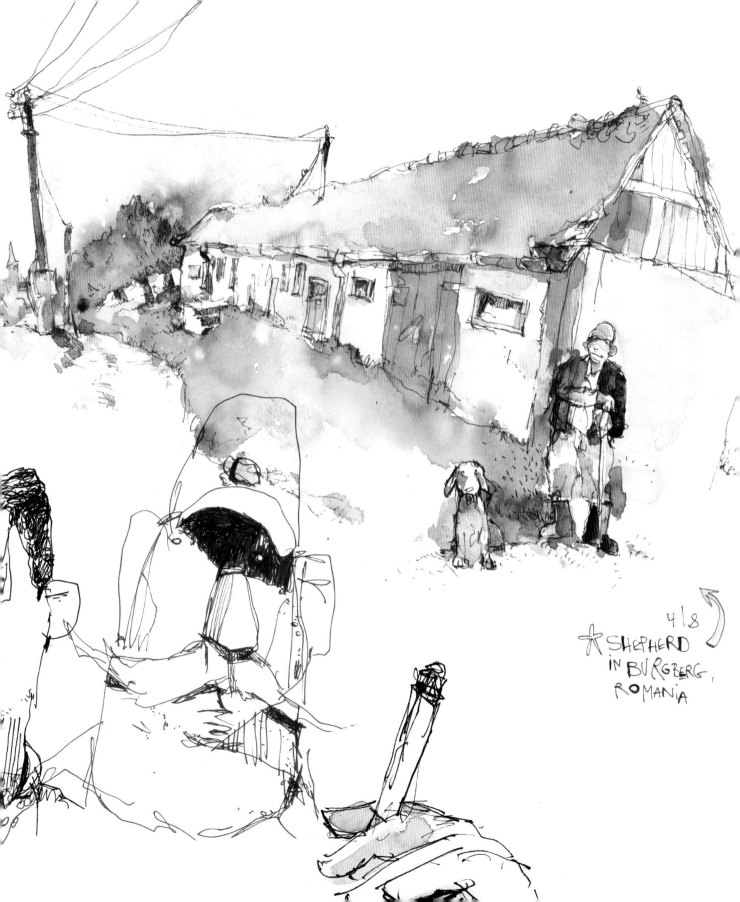

418
★ SHEPHERD
IN BURGBERG,
ROMANIA

SMOG AND ATMOSPHERE

Most drawing and painting mediums make it difficult to capture the misty, ghostly phenomena of air.
By contrast, watercolor paint is advantageous when creating the illusion of air in a painting, because it works the same way air does. Both are transparent matter in which particles float, such as smoke or fog (in the case of air) or colors (in the case of water). Depicting atmospheric situations is therefore simple, as they are so similar to the physical nature of our paint. In addition, paint in water behaves similarly to haze, smoke, or clouds in the air: it floats in the wet areas and lies on the paper in cloudy transitions. At the same time, diluted paint is nearly as transparent as clouds or air.

So in order to depict haze, we need to do nothing more than apply areas of clear water and allow minimal paint to gently float into it.

We begin by letting "air" into the area, or wetting it. The second step is to carefully add the paint and allow it to waft like smoke or fog into the wetter areas. Depending on the direction our picture takes, our depiction becomes more tangible step by step.

Among other things, it is advisable to select individual elements of a picture to blur into the haze, and to find more hard edges in the foreground.

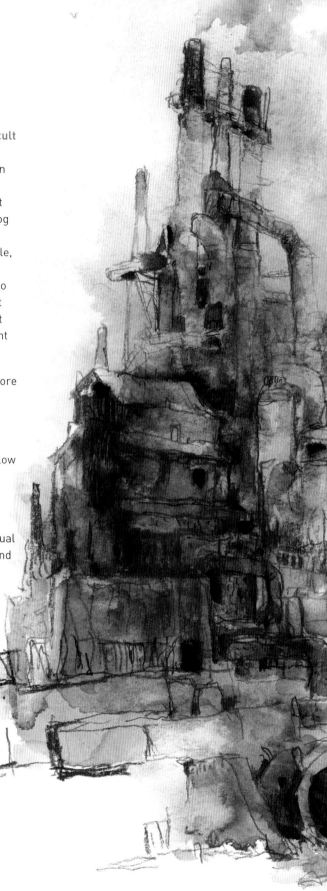

STEELWORKS,
BETHLEHEM - STEEL
PENNSYLVANIA | U.SA.

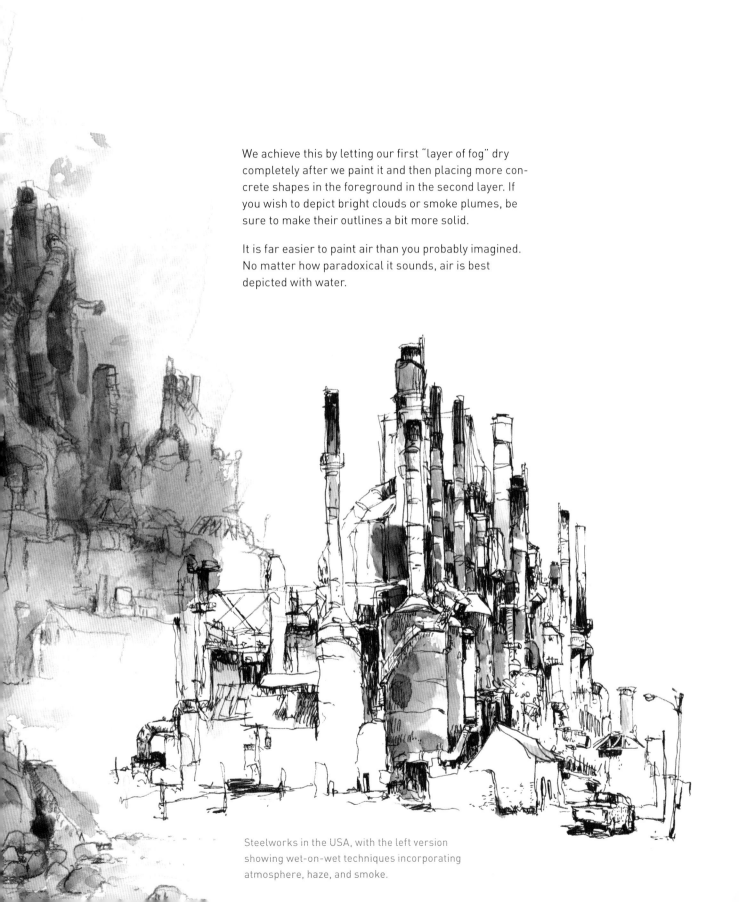

We achieve this by letting our first "layer of fog" dry completely after we paint it and then placing more concrete shapes in the foreground in the second layer. If you wish to depict bright clouds or smoke plumes, be sure to make their outlines a bit more solid.

It is far easier to paint air than you probably imagined. No matter how paradoxical it sounds, air is best depicted with water.

Steelworks in the USA, with the left version showing wet-on-wet techniques incorporating atmosphere, haze, and smoke.

WHAT IS BEAUTY ANYWAY?

Whether something is beautiful or not is up to you alone to decide. Often, watercolor painters are expected to paint old farms in Provence, sailboats in Mediterranean ports, or windmills in Holland. Of course these are all beautiful subjects. But in the end, it makes little sense to always paint what others expect you to. In reality, Provence was certainly more idyllic in the sixties when a cup of cappuccino didn't cost $8.50 and there weren't torrents of cars laboring their way through perfectly restored old towns. So, why should we keep painting things over and over again just because people once thought they were beautiful?

My advice is to look for your own subjects.

If you plan to paint something, you should paint it for itself and not for the expectations of past generations. Seen in the light of day, a house in Provence may mean very little to you personally. It may look pretty, but is it just as important as your first love's house or the house you grew up in?

On the other hand, we perhaps think the supermarket around the corner is a boring subject—but is it really? You may find something interesting if you look. Plus, we spend a great deal of our lives there—far more than in an overcrowded tourist destination. Is it therefore a poor subject simply because no one ever thought of painting it?

In twenty years, I bet you will derive far more pleasure from the painting of the supermarket. "Those were the days" will probably not be your first words when reviewing your Provence picture. Probably more like, "Where was that again?"

In short, paint what's around you—things that you can easily reference. Artists ought to be authentic and tell something about their world. It makes no difference if it's a prefab block of apartments in Romania or a supermarket in upstate New York. What's important is that you paint pictures and not reproductions.

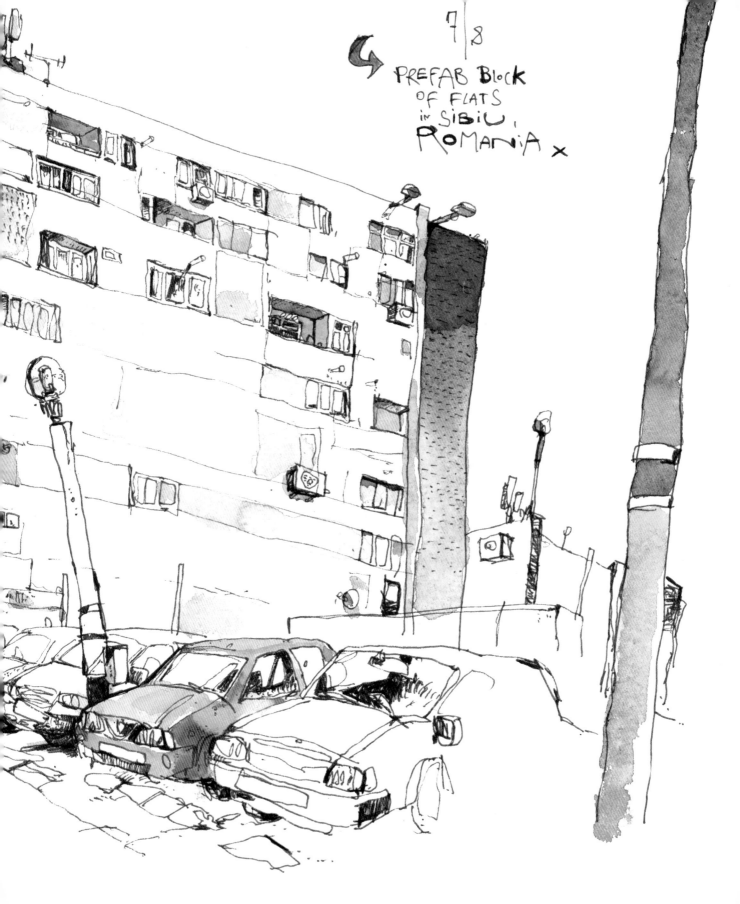

7/8

PREFAB BLOCK
OF FLATS
in SIBIU,
ROMANIA x

COMPOSITION AND DESIGN

To paint one big picture successfully, you need to practice on many little pictures.

In other words, designing a picture first is a must. Whether an image is good or bad not only depends upon the subject, but equally relies on how the individual elements are composed.

Whether a subject is close or far away, whether a mountain range grazes the edge of the painting, whether a building in the foreground is on the right or left is by no means incidental. Composition is elementary, and you should never leave it to chance.

In many ways, pictures live through their individual parts. Every line, every area, and every color in a painting influences its visual balance. Every element that you add to your subject transforms the picture. With every additional design element, we alter its inner tension. This makes design an immensely important topic.

WITH FEELING!

FEELING?

Tip: Use miniature sketches, or thumbnails, to put your compositions to the test.

Tip: The distance to your subject has considerable influence on the composition of your pictures. So, take a lesson from filmmaking and work with "shots."

How do we begin?

This is a matter of developing a feeling for design and composition. If you learn solutions by heart, they will only help you to solve the same problems over and over.

Train your eyes instead; once you can rely on your feeling, you will be able to encounter new design problems without reproducing the same old thing. So, leave the dry docks and learn from your experiments.

Start small.

Composition and picture design can be planned in advance using thumbnails.

Thumbnails are miniature views that enable us to run through various combinations quickly in reduced size. Whether a subject should stand on the right or left can be resolved easily this way. Therefore, before beginning your painting, make a series of little sketches (perhaps on the edge of the picture or on a page of your sketchbook) in which you run through the various possibilities. The composition is visible even in these small versions, and you'll save time and effort.

You'll see. This way, important picture composition issues can be clarified in advance without wasting time, paper, and nerves.

By the way, we artists often pretend to be omniscient.

Some say, "Art is synonymous with skill." I say, free yourself from that! In reality, skill comes from doing, and doing comes from trying. Good composition cannot be memorized. Try different things out as often as you can—your pictures will benefit from it!

Here are four shots using the example of my tomcat Juri:

Panorama:
Juri is far away. He disappears as a point in the landscape.

Long shot:
Juri in his milieu.

Knee shot / short focus:
Juri fills up the frame, perhaps with truncated upper body.

Close-up:
Juri is extremely close, his face fills the frame, and you recognize every detail.

SMUDGES AND SPOTS

Splotches, drops, and paint splatters—things that can usually ruin pictures—can have an astonishingly great effect on watercolor pictures. One splash or spray in the right place will give your picture a boost.

The difficulty with making splotches is not so much the splotching itself (we usually learn that before painting), but working confidently. We are already familiar with this from watercolors: it is a hard-to-grasp blend of control and letting go.

Of course, you can add the splotches separately in Photoshop, but to insert the splotches skillfully yourself, you'll have to rely on a bag of tricks.

First of all, once a drop drips it doesn't have to stay the way it is. For example, if we want to influence the direction it flows, we can control this very well by blowing gently at it through a straw.

But it gets even more interesting if we use splotches and splatters to imitate textures. Some textures are very difficult and time-consuming to imitate using watercolor paint in the traditional way. I'm thinking of coarse textures, for example, like stones and dust, or vegetation, but also fine surfaces such as skin. In these cases, a sprayed pattern can be very helpful.

If we tap the brush against our fingers, the paint sprays in rough splatters on the paper, creating textures similar to those seen in vegetation. (Many painters depict shrubbery this way.) If you want to achieve smaller and finer textures, use a toothbrush for splattering. A toothbrush is indispensable for mimicking almost everything from sand to freckles with splattering.

TOOTHBRUSH

Tip: You can, by the way, control the direction of a drop's flow superbly by blowing gently through a straw.

Finer drops and patterns can be splattered using a toothbrush.

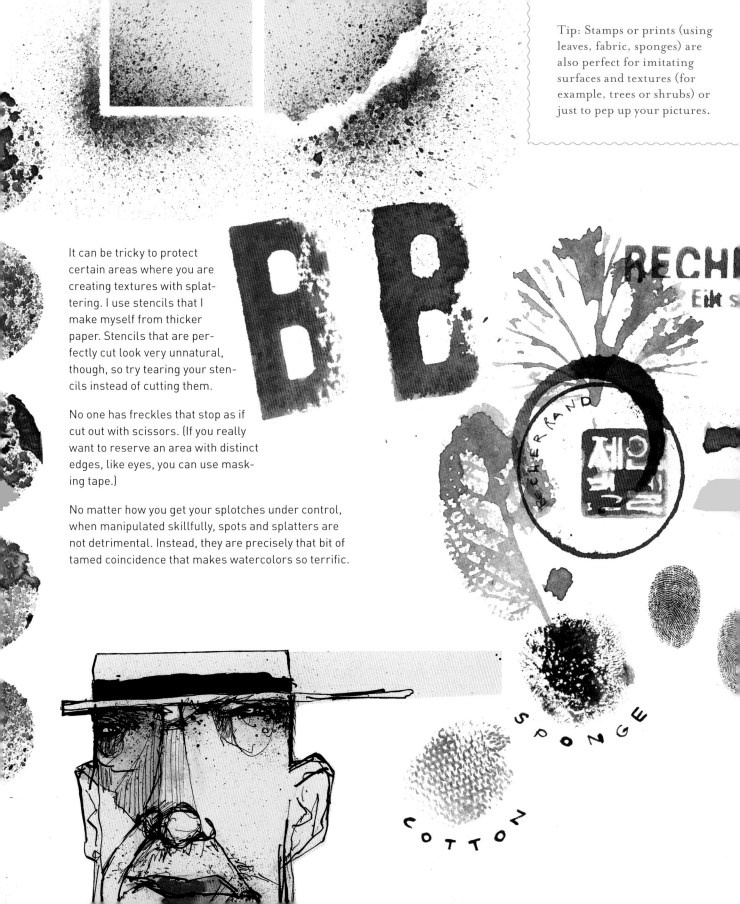

Tip: Stamps or prints (using leaves, fabric, sponges) are also perfect for imitating surfaces and textures (for example, trees or shrubs) or just to pep up your pictures.

It can be tricky to protect certain areas where you are creating textures with splattering. I use stencils that I make myself from thicker paper. Stencils that are perfectly cut look very unnatural, though, so try tearing your stencils instead of cutting them.

No one has freckles that stop as if cut out with scissors. (If you really want to reserve an area with distinct edges, like eyes, you can use masking tape.)

No matter how you get your splotches under control, when manipulated skillfully, spots and splatters are not detrimental. Instead, they are precisely that bit of tamed coincidence that makes watercolors so terrific.

SPONGE

COTTON

PAINTING WHAT'S NOT THERE
Negative Space

Some things are so obvious that we never notice them. Yet a lot depends on what we miss.

I'm talking about negative space.

In a picture, not only the parts that we paint are significant. The parts that we do not paint are also exceedingly important.

White has an effect, and negative space is a design element. In reality, it is a significant part of your painting.

However, it is important that the negative space does not just "happen." You have to consciously compose it. So, while painting, pay attention to what is there and what isn't. The success of a picture or a composition is equally dependent on both.

We do not just see subjects as they are. The negative space that results from them is also a part of our assessment without consciously realizing it.

Try to always picture both the form of your subject and the shapes of its negative spaces.

You're surely familiar with optical illusions; for example, if you look long enough, a goblet becomes two faces. Try to think this way while painting. Put a little distance between yourself and your subject, and check whether the negative shapes are also compositionally appealing. Reduce your subjects to flat forms, and then see what the negative shapes look like. You'll be surprised at how much your paintings benefit from this.

Tip: To compose the negative space, you first have to see the positive. Simplify your subject. In your mind, reduce it to a flat surface or shape; the rest will happen on its own.

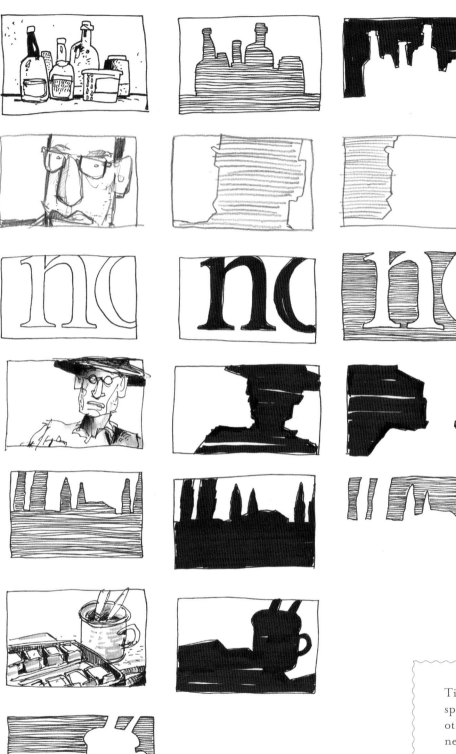

Tip: These principles of white space also apply quite well to other areas of design. The negative shape of a font, a logo, or another design element is also significant. Here, too, what we see is not all that decides "good" and "bad"; the resulting negative shapes also contribute to it.

WHITE
A Special Case

As white as snow, white like the light, white as paper. With watercolor, innocent white is a far trickier matter than you might think.

The problem lies in the nature of the glaze: every layer we apply darkens the picture. It doesn't matter what color we layer next; even light colors make the picture a little darker with every layer, and every step we take takes us a little farther away from the light.

Unlike all other painting techniques, watercolor is a one-way street. The transparency of the paint makes it practically impossible to apply a lighter hue on top of a darker hue. Applied paint can only be retouched with difficulty, and once a tone is darkened it can never be made light again. With opaque mediums like oils or acrylics, we simply use a tube of white paint, but with watercolors, we are somewhat helpless. White watercolor paint straight from the palette just looks dirty and unnatural. That is why the rule for watercolors is this: white is not painted. Instead, white is omitted, or "reserved." This is also one of the reasons that watercolor is not an easy technique: we cannot make corrections. The white in our pictures is the paper, and this forces us to know beforehand exactly where in the picture we want it to shine through.

In watercolor painting, the white in the picture forces us to plan ahead.

So, how do we go about it? Simply paint around it and reserve the lightest shade?

In practice, this is anything but simple, because often the lightest parts of the picture are only very tiny things, like the light reflected in a glass, the white of an eye, or a strand of hair.

WAX CRAYONS

Tip: Masking fluid has the unpleasant attribute of clumping up your brush. Therefore, never use expensive watercolor brushes to apply it. Instead, use less expensive models, such as craft brushes. It is also helpful to dip the brush briefly in soapy water before painting with frisket.

MASKING TAPE

Obviously, in such cases we can't constantly be "hovering around" these areas, especially not if they are incorporated into larger areas of color.

For these finicky cases, masks, or resists, are a solution. The simplest mask can be made, for example, from masking tape. Paper masks can also be used, but these are difficult to adhere to the paper.

Another trick is to pre-draw the white parts of the picture with wax crayons or candles. The watercolors will not adhere to the pre-treated places, and these then remain white. However, this method is not very precise, and the wax cannot be removed.

When working with watercolors, frisket, or masking fluid, is the best material for masking.

Frisket is a water-soluble latex film applied to areas you want to protect from paint. It is applied in liquid form and then allowed to dry. Once the film is dry, you can paint over it. The places where the frisket adheres remain unpainted. Later, you can simply rub the latex layer off with your finger or a rubber eraser. Fortunately, the masking film can be removed with no residue, and you can paint again over areas that had been masked later.

"FRISKET"
(LIQUID MASKING FILM)

RUBBEL KREPP

10 KOLIN

1. APPLY 2. PAINT 3. RUB OFF

STUDIES, SKETCHES, AND DRAFTS

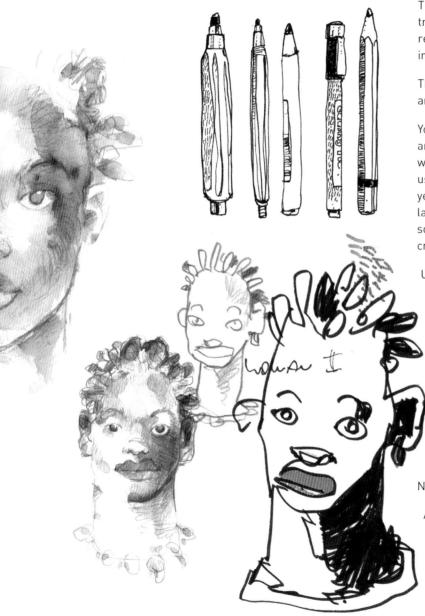

Watercolor is a transparent technique.

The layers of paint do not hide one another, and their transparency always ensures that underlying layers remain visible. This is true not only for the paint but, in particular, for sketches and studies.

This is reason enough to take a closer look at sketches and watercolors.

You can make a preliminary sketch using almost anything, of course. The most obvious way is to use watercolors themselves for the sketch. For this, we use the diluted paint of a light hue—say beige or yellow—to put down a rapid sketch on the paper and later paint the picture over it. Doing so will cause some of the initial sketch to dissolve into the paint, creating a certain lightness.

Using a pencil for a preliminary sketch creates a slightly more visible image. However, pencil tends to become affixed by watercolor paint. Even a thin layer of paint means that we can no longer erase the pencil lines underneath. There are water-soluble colored pencils that blur or disappear when they come into contact with water. But in most cases, the line remains and forms the scaffolding of our picture.

Besides using pencil, you can sketch using any number of permanent pens. I personally prefer to work with permanent fine-point pens, like Koh-I-Noor, Copic, Sakura, or similar.

A good method for transferring a preliminary sketch to watercolor paper is to use a light table.

For this you make a rough drawing on a thin sheet of paper and then simply trace it on your watercolor paper on the light table. If you don't have a light or layout table, you can just use a window that daylight shines through. It's a good idea to tape the two sheets of paper together so they don't slip around.

Unfortunately, even the strongest light table will not shine through a pad or block with a cardboard backing or a paper stretched on a board. In these cases, you'll have to find another solution.

Try working with Saral paper. This is a kind of carbon paper for tracing drawings, which, unlike real carbon paper, is available in various colors. The traced lines can be erased away.

But you can also make your own transfer paper.

First, we blacken the rear side of the sketch with a soft pencil (3B or softer). When we lay this sketch on our watercolor paper and draw over it with a harder pencil, the lines are transferred through to the underlying surface. An exact penciled copy of our sketch appears on the watercolor paper.

The main advantage of tracing, in my opinion, is that it makes us feel more relaxed about our pictures, and you don't risk damaging the watercolor if you need to erase your drawing. Often, the attitude "If it doesn't work out, I'll just try it again" will lead to you not having to try it again at all. It sounds odd, but simply having the option to redo a picture lowers the probability of actually having to redo it.

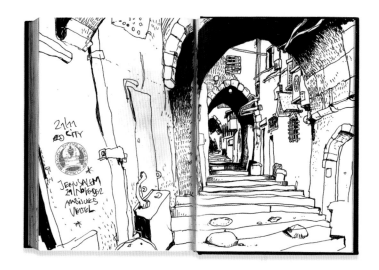

Tracing in three steps:
1. Sketchbook
2. Copy or tracing paper
3. Watercolor paper

UNDO

A hard brush with pig bristles is also suitable for firm removal.

However, at least a faint trace of color will usually still be visible on the paper, so washing out the paint is not always helpful.

Another method is to remove the paint not with water but with a dry technique. For instance, you can use a razor blade or some sandpaper to scratch off layers of paint. This works particularly well on smooth, hard watercolor board, but only on small areas. A hard rubber eraser may remove pigments that have soaked deep into the paper, but these can be very tough on paper. Erase with caution.

However, some colors (many red and green shades, in particular) permeate deep into the surface of the paper and are difficult to remove. So, do not expect perfectly clean results.

In practice, a combination of wet and dry removal techniques have proven successful. However, if you try to remove paint with water first, make sure the paper dries completely before attempting a dry removal, because it may tear.

Of course, the best thing to do is stand by your mistakes.

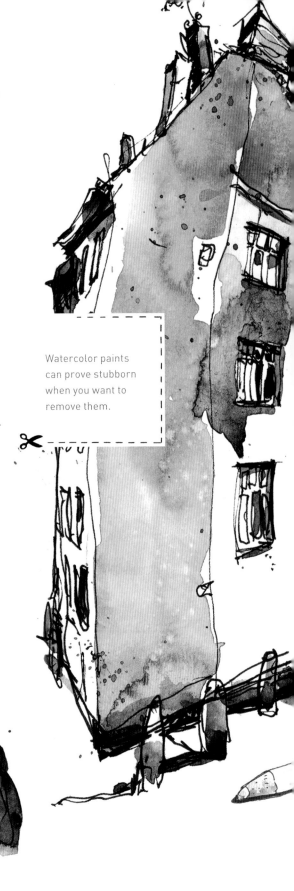

Watercolor paints can prove stubborn when you want to remove them.

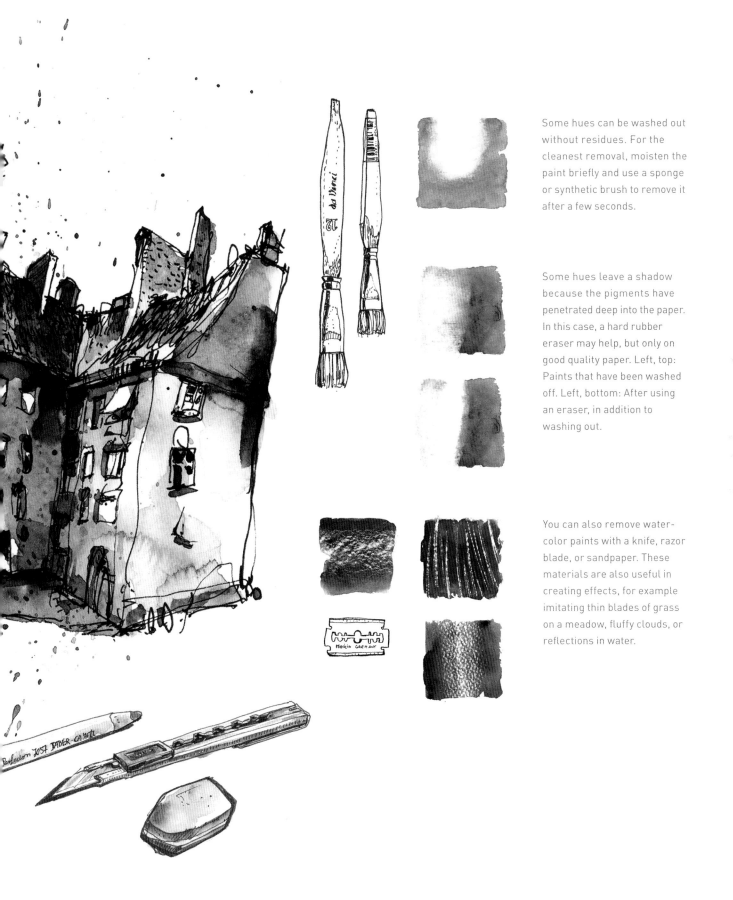

Some hues can be washed out without residues. For the cleanest removal, moisten the paint briefly and use a sponge or synthetic brush to remove it after a few seconds.

Some hues leave a shadow because the pigments have penetrated deep into the paper. In this case, a hard rubber eraser may help, but only on good quality paper. Left, top: Paints that have been washed off. Left, bottom: After using an eraser, in addition to washing out.

You can also remove water-color paints with a knife, razor blade, or sandpaper. These materials are also useful in creating effects, for example imitating thin blades of grass on a meadow, fluffy clouds, or reflections in water.

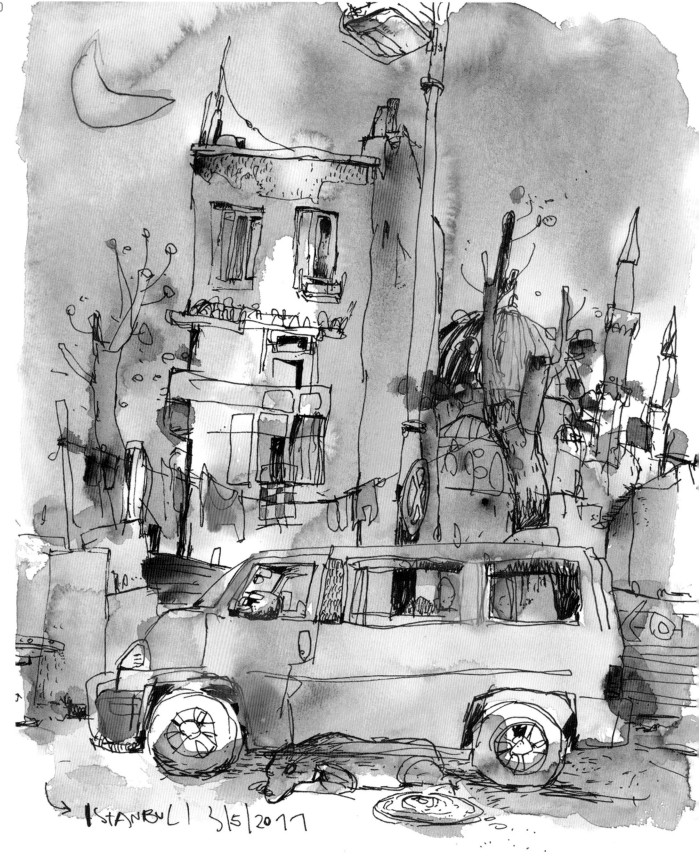

ISTANBUL 3/5/2017

MERGING COLORS
Working from One Color

There is a gray veil over the city / That my mother hasn't washed off yet.
—Die Fehlfarben, 1980

Don't you agree that on a June day at 7:52 p.m., the world is at its loveliest? When the sun is low in the sky and immerses everything in a yellow glow? Or when the fog comes in from the harbor and lays a milky hue over the horizon?

What about twilight—when the stars appear in the evening sky and the night steeps in all blue and violet?

A common mood in the lighting is not just lovely to look at; it is also incredibly important in painting, as it unifies colors.

One way to create a harmonious, cohesive color scheme is to merge the colors. This means creating the illusion that your entire picture is immersed in one single kind of light.

This works best by first painting a single color over the entire surface of the paper before painting the details. This establishes a tone, a basic mood, over which you will paint your picture. A wet-on-wet technique works best here. Since layers of watercolor paint blend with subsequent layers, this one initial tone will be present in the rest of your picture; all of the layers of color you later add will blend with this initial single color, and will therefore be harmonious. The underlying tone will draw the colors applied over it together.

You can also do it the other way around, and lay a single layer of color over your finished picture. This subdues colors that were less successful and also draws other tones together. Grays, for example, like Payne's gray, applied quickly with a large brush work well with this approach. However, there's a risk that the new layer will rewet and blur all of your underlying work.

Therefore, my preferred approach is to begin with the unifying layer of color before working on the details.

When merging colors, you can also start by building wet-on-wet gradations into your picture. You can create shimmers of light or shadows in the first unifying layer, creating a graphic element upon which the picture can build. For instance, a dark spot added to the paper during a painting's initial stages can evolve into the shadows of a room or the center of a flower.

These techniques cause tremendous effects and establish a general tone and mood for a sketch right from the start.

Opposite:
The unifying layer was painted first.

Below:
The unifying layer was added later.

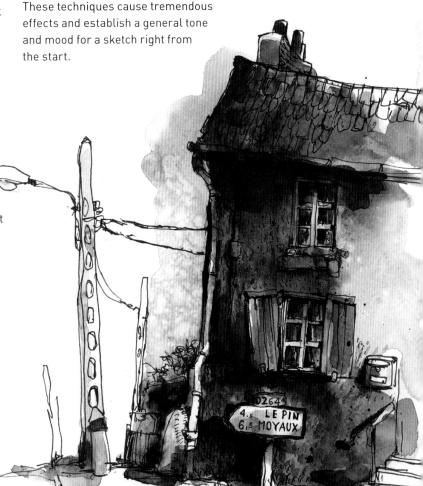

Tip: Colored paper is very good for collages because the contrast to the new background produces a convincing plasticity.

Sperrgu
Encombran.

WORKING WITH COLORED PAPER

Another great trick for merging colors is to choose your paper accordingly. Try painting on colored paper rather than white paper.

It is even easier to produce pleasant color harmonies on colored supports than it is on white watercolor sheets. Just as an initial wash of paint unifies colors, colored paper provides a basic, cohesive mood or tone that visually guides all of the layers of paint on it in one direction. Basic toned papers create light situations by themselves.

Yellow, gray, or brown papers work best. Recycled paper can also be very effective. Old envelopes, book pages, wallpaper, gift-wrapping paper, and old kraft paper are excellent options.

Actually, all that matters is that the color of the paper has enough intensity to unify the colors you paint with, but not so much intensity that it swallows up your watercolor glaze. It sounds simple, but colored paper creates a basic framework that facilitates working with colors, since it lends your picture a natural, unifying color.

Tip: On colored paper, you can even use opaque white watercolor paint, which appears much more pure and pristine than it does when painted on top of white paper.

SPECIAL EFFECTS

There are a number of additives and tricks that alter the effect of watercolors. Ox gall is very common, and some manufacturers add it to their paint sets as a standard feature. Ox gall is made from the gall bladder of cattle (don't lick the brush, it tastes nasty!) and is chiefly used to improve flow, delay drying, and to remove oil, perhaps introduced by fingerprints, from the paper.

To be honest, I don't think ox gall is very essential in practice. Unless you have plenty of space in your paintbox, you can do without it, as far as I'm concerned.

There are one or two things that are not in your box that can influence your painting far more. If you want to create splotches and spatters, for example, you can sprinkle salt or saliva (really!) on your painting. You can also scrape the lead off of watercolor pencils and sprinkle the shavings into the still-wet paint to achieve great textures. This technique creates particularly interesting effects and really turns up the color in a painting.

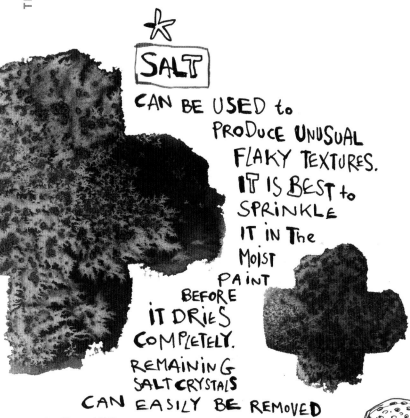

SALT

CAN BE USED to PRODUCE UNUSUAL FLAKY TEXTURES. IT IS BEST to SPRINKLE IT IN THE MOIST PAINT BEFORE IT DRIES COMPLETELY. REMAINING SALT CRYSTALS CAN EASILY BE REMOVED AFTER DRYING BY RUBBING THEM LIGHTLY WITH YOUR FINGERTIP

INDIGO WITH SALT STRUCTURE

* SALT →

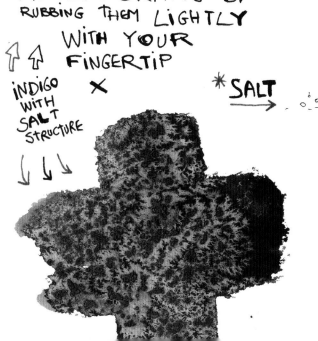

1. A SIMILAR EFFECT AS SALT CAN BE ACHIEVED, BY THE WAY, WITH SALIVA.

2. IT MAY SOUND GREAT CLOUDY EFFECTS.

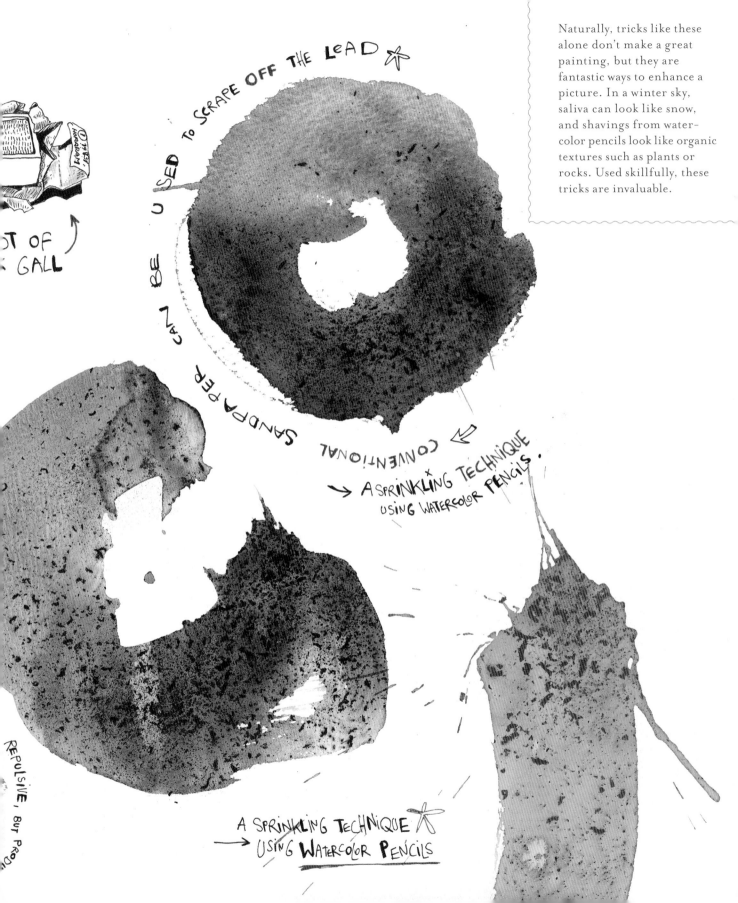

CAN BE USED TO SCRAPE OFF THE LEAD ✴

CONVENTIONAL SANDPAPER

OT OF
GALL

Naturally, tricks like these alone don't make a great painting, but they are fantastic ways to enhance a picture. In a winter sky, saliva can look like snow, and shavings from watercolor pencils look like organic textures such as plants or rocks. Used skillfully, these tricks are invaluable.

→ A SPRINKLING TECHNIQUE
USING WATERCOLOR PENCILS.

REPULSIVE, BUT PROD...

A SPRINKLING TECHNIQUE ✴
→ USING WATERCOLOR PENCILS

LETTERING AND WRITING

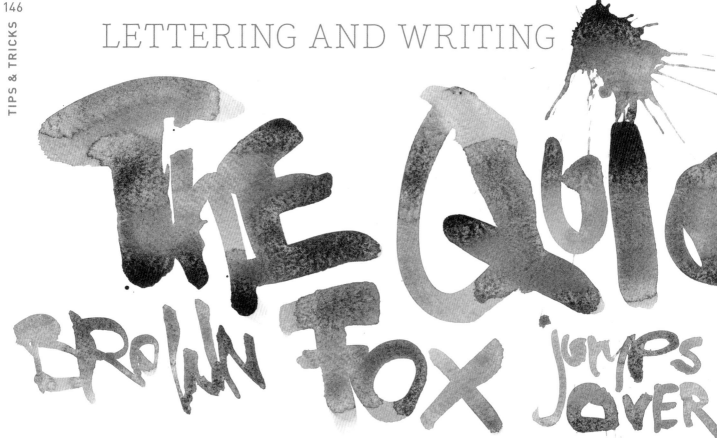

Pictures and characters were essential for human development. They could be used to convey ideas without speaking directly from person to person, so information could be stored and transported—time and space were no longer obstacles.

Without pictures and written characters, we would probably still be following herds of reindeer around. Everything that has been developed in the modern world, from book printing to the invention of the toaster, could only follow because we enabled ourselves to preserve and pass on knowledge to others.

About five thousand years ago, the Sumerians in the city of Uruk (modern-day Iraq) made a huge quantum leap toward refining information by moving from pictograms to cuneiform, an early form of writing. As we should know, pictures and writing are closely related.

All written characters began as pictograms, or drawings that embodied their meaning. The Egyptian hieroglyphics were pictograms, although they were also associated with consonants. In some types of writing,

the original pictograms can still be recognized. For example, the old form of the Chinese character for "person" actually looks a bit like a stick figure, and the character for "moon" really does resemble a waxing moon.

Over the millennia, however, the original pictograms gradually lost their form, became bound to phonemes and syllables, and were abstracted to become what we recognize as letters and characters.

Writing is not only informative, however. It also has its own intrinsic beauty.

Just as we can use pens and pencils to both write and draw, a brush doesn't only have to be used for painting; we can also write with it.

Brush lettering is a good way to reunite the long-lost siblings of writing and drawing. If we supplement pictures with handwriting or paint calligraphic watercolors, we are, in a way, going back to one single piece; we get nearer to the image and move

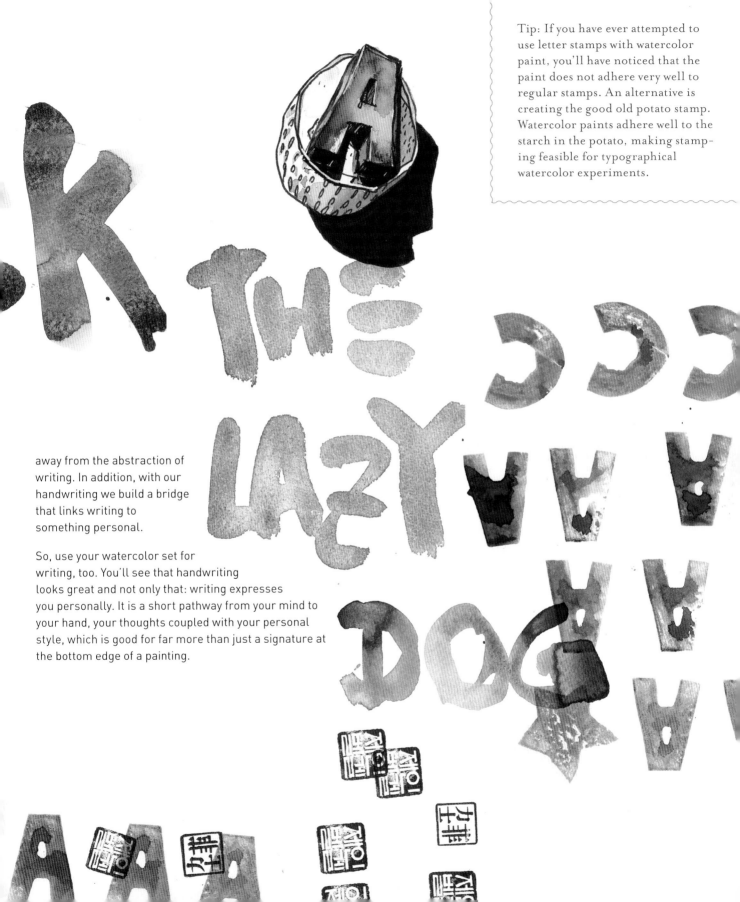

Tip: If you have ever attempted to use letter stamps with watercolor paint, you'll have noticed that the paint does not adhere very well to regular stamps. An alternative is creating the good old potato stamp. Watercolor paints adhere well to the starch in the potato, making stamping feasible for typographical watercolor experiments.

away from the abstraction of writing. In addition, with our handwriting we build a bridge that links writing to something personal.

So, use your watercolor set for writing, too. You'll see that handwriting looks great and not only that: writing expresses you personally. It is a short pathway from your mind to your hand, your thoughts coupled with your personal style, which is good for far more than just a signature at the bottom edge of a painting.

LAYOUTS, SCRIBBLES, AND STORYBOARDS

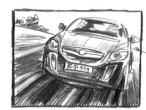

We do not encounter many hand-drawn techniques in applied design today, and there is a simple reason for that: the revisions.

Layouts and storyboards are altered much more than you'd imagine. Every oh-so-minor advertisement, illustration, animation, and film goes through a metamorphosis until it is considered presentable.

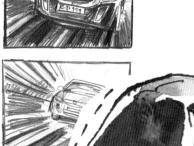

In the course of the revisions, the woman in the foreground of a commercial, for example, may be replaced by a man, who in the next phase is replaced by a car, which is replaced by a boy, which, in the next meeting, mutates back to a woman (who is also given a different-colored dress in the final version).

It's not so much a matter of changing aesthetics here but merely having the ability to revise. It's obvious that digital techniques are more suited for this than any analog ones.

Still, it depends on what phase of a project we're talking about. In the field or during a meeting or presentation, the scales tip very quickly in favor of traditional, hand-drawn techniques. To explain something quickly, to "throw an idea out there," sketching is simply unbeatable. Watercolors are also a very good option for this. You don't need to lug around an assortment of different-colored pens with you, as you would with markers. Instead, you simply whip out your miniature paint set and lend color to your ideas. In presentations and during meetings in particular, a little scribble can underscore what's being said, thereby achieving a fantastic effect.

But we all know that, in the end, all that matters are your ideas. The vehicle you use to transport your ideas should be chosen according to the situation.

Tip: Water brushes are particularly suitable for working in the field, in meetings, etc., to avoid splotches and having to run around with glasses of water. These brushes include a reservoir of water, which flows under slight pressure. Water brushes can be found in well-stocked art supply stores or online, and they are a splendid portable option to have on hand.

JOURNEY to NEW YORK

WATERCOLOR ILLUSTRATIONS

Watercolor illustration for the magazine *Mare* (Hamburg).
Above: Initial sketch.
Center: Precise draft, still using an entirely different color scheme.
Below: Final artwork, result of revision phases.

There is something anarchic about watercolor paint. It always does what it wants and is therefore not nearly as predictable as, say, computer-generated vector graphics.

Watercolors and revisions, therefore, do not go together very well.

With watercolors, something that's been painted can't really be erased, or worse, painted over. Although we can intervene using image-processing programs like Photoshop, revising watercolors by hand is more difficult. It's not a new problem: since their invention watercolors have been difficult to retouch, but the digital revolution has increased the ease of and, consequently, the demand for revisions considerably.

In spite of this, watercolor paint is excellently suited for illustrations simply because the untamable nature of the paint has something spontaneous and beautiful about it. This is why watercolors are indispensable to some fields of illustration—for instance, in the literary sphere and in children's books in particular.

So, make careful preliminary sketches. If you give your clients colored sketches that already contain all of the pictorial information they need, you can still implement revisions easily.

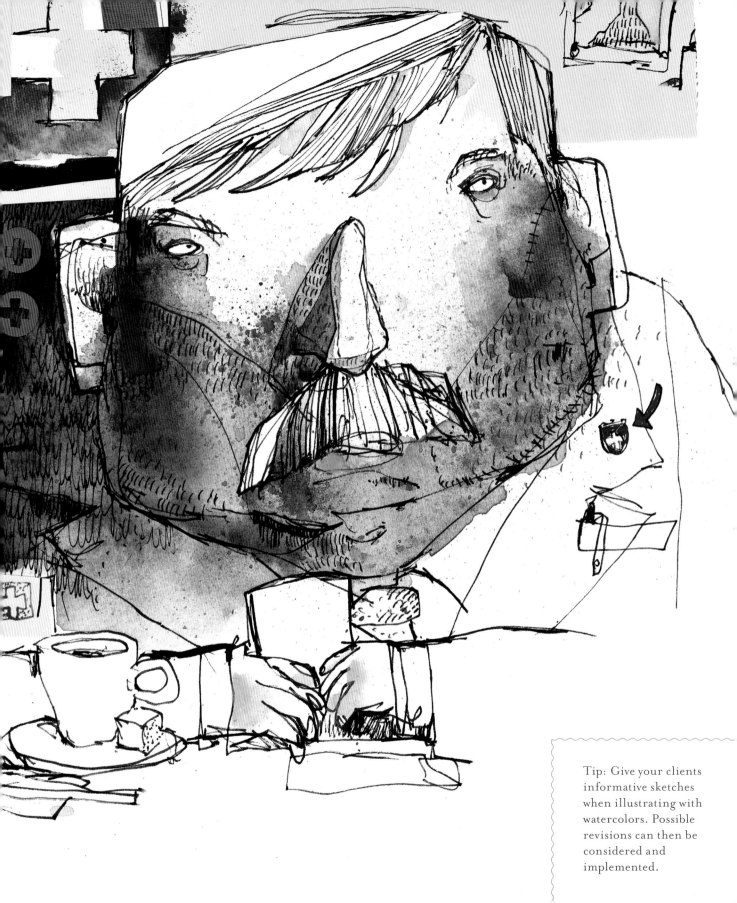

Tip: Give your clients informative sketches when illustrating with watercolors. Possible revisions can then be considered and implemented.

HOW MUCH IS YOUR PICTURE WORTH?

What's the value of your painting? $50, $100, $1,000?

Oddly, almost all artists and graphic designers find the topic somewhat unpleasant. We avoid it altogether, quote prices that are too high or too low, and are happy when others (gallery owners, agents, or friends) do the pricing for us.

It's not that we are bad at business, but all too often, we neglect to see price as the material equivalent of others' recognition. We erroneously make the price the indicator of our own artistic quality.

If the price is too low, we see ourselves disappearing into irrelevance; if it's too high, the pressure to perform suffocates us. It's not the price we are talking about, but ourselves. Strangely, this is what makes it difficult to price our work.

They say the market sets the price. The more people want to hang this picture on their walls (or in the case of usage rights, the more people want to reproduce the work), the higher the price. Therefore, a high price must mean that the picture is pleasing to many.

It is remarkable that we allow our value as artists to rely so much on this principle of market value, since the market does not necessarily have the most well-trained eye. Market value can also make something inconsequential expensive, and vice versa.

A great painting can be worthless on the market because no one acknowledges it.

To sum it up, I personally do not think that price and value are the same thing. On the contrary, truly significant things are usually unmarketable: there are no price tags on happy memories, summer days, and first loves. Similarly, regardless of their prices, paintings, pages of a sketchbook, or notes possess a special value.

So, we need to turn it around and ask the following: What is its value to me personally? What in my life provides me with value?

Pictures can almost always be valuable, but that does not necessarily make them profitable merchandise.

Even if the value is far more important than the price, art and design are, of course, work. Thus, a work of art also should have a monetary value.

But oddly enough, both society and artists tend to leap to the same extremes: one quickly under- or overestimates one's price because there are no universal yardsticks for personal value.

Low pay is often justified with "it was fun to do."

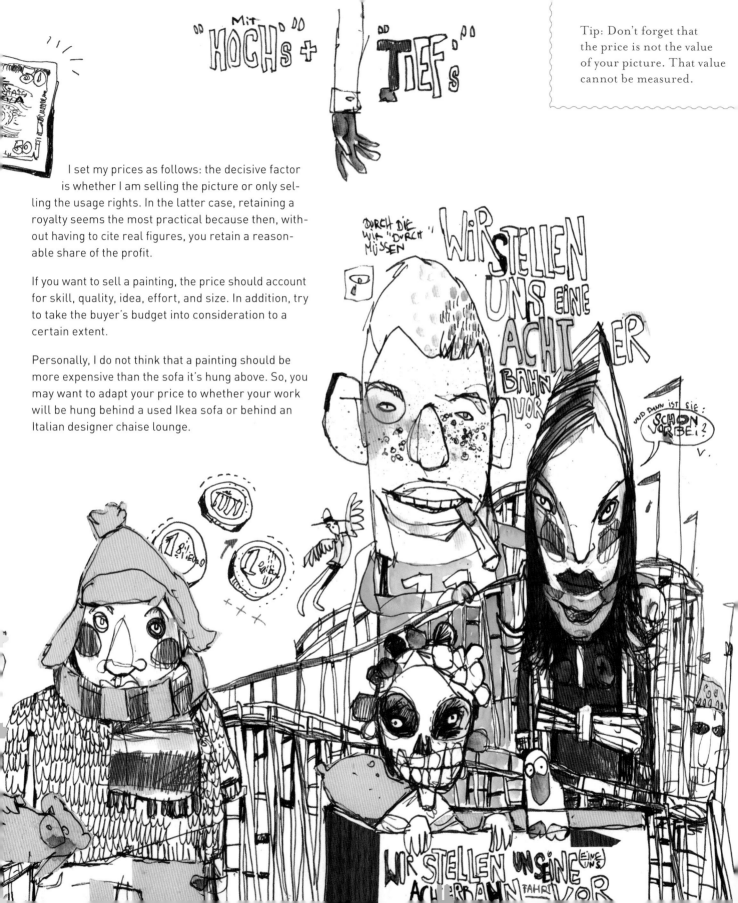

Tip: Don't forget that the price is not the value of your picture. That value cannot be measured.

I set my prices as follows: the decisive factor is whether I am selling the picture or only selling the usage rights. In the latter case, retaining a royalty seems the most practical because then, without having to cite real figures, you retain a reasonable share of the profit.

If you want to sell a painting, the price should account for skill, quality, idea, effort, and size. In addition, try to take the buyer's budget into consideration to a certain extent.

Personally, I do not think that a painting should be more expensive than the sofa it's hung above. So, you may want to adapt your price to whether your work will be hung behind a used Ikea sofa or behind an Italian designer chaise lounge.

EVERYTHING ENDS
When Is a Picture Finished?

The question of when a picture is finished never arises with a Polaroid. Look through the viewfinder, click, release, and the picture's done. It either turns out well or it doesn't.

It is quite different with a painting. A painting evolves—from a preliminary sketch, to an underpainting, to paint. We add an element and take another away.

A painting accompanies us; we invest time and energy in its growth. As it grows, we give it direction.

Yet, since we alone are able to control it, we are also the only authority that can declare it finished.

This is the dilemma. We spend so much time with our picture that we oddly also lose distance from it.

There is a moment in every picture when any further painting does not make the picture better, but worse. Painters talk about "painting a picture to death." A major component of art—especially in watercolor painting—is recognizing when this is about to happen and putting down the brush.

One reason that we often work longer on a painting than necessary is that we know once we declare a picture finished we subject it to evaluation. Unfinished pictures can't be criticized. As long as the painting is a work in progress, we are delaying that moment of truth. Merely out of fear of this moment, we get stuck in a kind of purgatory and dabble away at our paintings longer than we need to.

Paradoxically, this is exactly what makes a picture worse. If we had the courage to declare that the painting is completed, we could prevent it from being painted to death.

When is your picture finished? The moment you feel that it cannot get any better, but only worse.

A sketch is not the same thing as a snapshot. It is not finished the moment you release the shutter—while it grows, we give it direction.

The question of when a picture is finished is, to wit, extremely important. Should we change an element or add another? Is this really the right form, the right color? Yet, if we just keep painting and cannot bring it to a close, we risk destroying it. Watercolor paint in particular appears dead when we keep piling one layer on top of another. Watercolors that are re-wetted and painted over become dull and lose their luminosity.

→ POLAROID 1000

INDEX

Air, 122, 124–25

Black, 28–29, 96
Blue, 18–19, 60, 76–77
Brushes, 106–9, 149
Brushwork, 99

Color codes, 72–73
Color generators, 63
Color harmonies
 analogous, 65
 collecting, 71
 complementary, 65
 cool-cool, 68
 designing, 72–73
 monochromatic, 65
 split-complementary, 65
 tetradic, 66
 triadic, 66
 unfamiliar, 74–75
 warm-warm, 68
Colors
 complementary, 53, 65
 cool, 68
 cultural context and, 62
 economical use of, 78–79
 effects of, 22, 48, 60
 favorite, 74
 intensifying with, 59
 lightfastness of, 13, 97, 104–5
 luminous vs. nonluminous,
 48–49
 merging, 141, 143
 mixing, 32–33, 98–99
 perspective and, 76–77
 science behind, 48–49
 spicing up, 102–5
 types of, 54–57
 warm, 68
 of wet vs. dry paints, 13
 See also individual colors
Color wheels, 50–51, 63
Composition, 128–29
Contrasts, 53
Creativity, 83, 87

Design
 composition and, 128–29
 decisions and, 25

Emotions, 60, 89
Equipment, 114–15. *See also*
 Brushes; Paints; Paper

Finishing, 154
Fog, 122
Food, painting, 34

Glazing
 combining washing and, 47
 with India ink, 28–29
 layers of, 31, 34
 mixing colors with, 32–33
 practicing, 34
Gray, 26–27, 29
Green, 20–21, 60
Gum arabic, 10–11

Iconographic color, 54–55
Illustrations, 150–51
India ink, 28–29

Layouts, 148
Lettering, 146–47
Light
 effect of, 56
 shadows and, 26–27
 white as, 31, 38
Liquid watercolors, 104–5
Local color, 54
Loosening up, 84–85

Masking, 134, 135
Mistakes, 138–39
Monochromatic harmony, 65

Negative space, 132–33

Orange, 15
Outdoor painting, 116
Ox gall, 144

Paintboxes, 92, 93
Paints
 applying, 42–43
 buying, 96–97
 characteristics of, 100
 color of, wet vs. dry, 13
 composition of, 10–13
 diluting, 41
 liquid watercolor, 104–5
 mixing, 98–99
 removing, 42–43, 138–39
 symbols on, 97
 in tubes vs. pans, 93
Paper
 choosing, 110–11
 colored, 142–43
 history of, 110
 stretching, 112–13
Pencils, 95, 103, 144
Perspective
 changing, 118
 color and, 76–77
Pigments, 11, 12–13
Priorities, role of, 90
Purple, 16–17

Red, 16–17, 60

Selling prices, 152–53
Shadows, 26–27
Sketches, preliminary, 136–37
Smoke, 122
Special effects, 144–45
Splotches, 130–31, 144
Stamps, 131, 147
Storyboards, 148
Style
 creativity and, 83
 finding your own, 80
 loosening up and, 84–85

Subjects
 choosing, 89, 126
 distance to, 129

Thumbnails, 129
True color, 56–57

Value, concept of, 152–53

Washing
 combining glazing and, 47
 effects of, 36
 techniques for, 38–45
Water, painting, 120–21
Water brushes, 149
Watercolor
 attitudes toward, 7
 characteristics of, 7, 100
 history of, 12
 time and, 8–9
Watermarks, 111
Weather, bad, 116
Wet-on-wet technique, 44–45
White, 31, 38, 79, 96, 132–35
Writing, 146–47

Yellow, 14–15

All rights reserved.
Published in the United States by Watson-Guptill Publications, an imprint of the
Crown Publishing Group, a division of Random House LLC, a Penguin Random
House Company, New York.
www.crownpublishing.com
www.watsonguptill.com

WATSON-GUPTILL and the WG and Horse designs are registered trademarks of
Random House LLC.

Originally published in hardcover in Germany as *Wasserfarbe für Gestalter* by Verlag
Hermann Schmidt Mainz, in 2011. This translation arranged with Verlag Hermann
Schmidt Mainz. Translation by Faith Ann Gibson.

Library of Congress Cataloging-in-Publication Data
Scheinberger, Felix.
 [Wasserfarbe für Gestalter. English]
 Urban Watercolor sketching : a guide to drawing, painting, and storytelling in color
/ Felix Scheinberger. — First American Edition.
 pages cm
 Includes bibliographical references and index.
 1. Watercolor painting—Technique. I. Title.
 ND2420.S32313 2014
 751.42'2—dc23
 2013019316

Trade Paperback ISBN: 978-0-7704-3521-9
eBook ISBN: 978-0-7704-3524-0

Printed in China

Design by Nicola Aehle, Felix Scheinberger, and Katy Brown

10 9 8 7 6 5 4 3 2 1

First American Edition